The Campus History Series

STETSON UNIVERSITY

MAGGI SMITH HALL

Dedication

*This book is dedicated to my supportive husband Ron,
chair of Stetson's Philosophy Department,
and the three women in our lives:
Amy, our firstborn,
and the first infant to live on Stetson's campus in a men's dorm
while her father was head resident;
Erin, our youngest,
Stetson's class of '97;
and Emma, Erin's firstborn,
delivered in the same DeLand hospital as her Aunt Amy.*

The Campus History Series

STETSON UNIVERSITY

MAGGI SMITH HALL

Copyright © 2005 by Maggi Smith Hall
ISBN 978-0-7385-1755-1

Published by Arcadia Publishing
Charleston, South Carolina

Printed in the United States of America

Library of Congress Catalog Card Number: 2004113139

For all general information contact Arcadia Publishing at:
Telephone 843-853-2070
Fax 843-853-0044
E-mail sales@arcadiapublishing.com
For customer service and orders:
Toll-Free 1-888-313-2665

Visit us on the Internet at www.arcadiapublishing.com

ACKNOWLEDGMENTS

Gratitude is extended to the late Prof. Gilbert L. Lycan, Stetson historian and author of *Stetson University: The First 100 Years*, for his extensive research; to Sidney Johnston, for his architectural descriptions; to Stetson's "A Walk with the Founders" booklet and other publications; Stetson's staff, who diligently edited for accuracy and scanned hundreds of photographs; to the West Volusia Historical Society for allowing the use of its historical photographs and to Jackie Kersh, who volunteered to scan the images; to past presidents, faculty, and staff for promoting excellence in education and instilling within Stetson students a commitment to others as well as a passion for their alma mater; to Stetson's students—past, present, and future—whose accomplishments and loyalty distinguish our school; and especially to Pres. H. Douglas Lee for enthusiastically supporting this project.

PRESIDENTS

John F. Forbes	1885–1903
Lincoln Hulley	1904–1934
William Sims Allen	1934–1947
J. Ollie Edmunds	1948–1967
Paul F. Geren	1967–1969
John E. Johns	1969–1976
Pope A. Duncan	1977–1987
H. Douglas Lee	1987–present

CONTENTS

About the Author 6

Introduction 7

1. Historic Past: 1883–1947 9

2. Contemporary Times: 1948–2005 51

The Future: 2006 and Beyond 127

About the Author

Maggi Smith Hall is a native Floridian raised in Jacksonville. She received a B.A. from Stetson University in DeLand, Florida, and an M. Ed. from Francis Marion University in Florence, South Carolina.

During her 30 years as a South Carolina educator she established two educational institutions, the Marion County Museum and the Fork Retch Environmental Education Center. While a museum director she also directed the South Carolina Rural Arts Program for Marion County. For those endeavors she received local, state, and national recognition including the South Carolina State Archives Award for "Adaptive Restoration of an Historic Facility" (an 1886 schoolhouse listed on the National Register of Historic Places as the longest operating public school in South Carolina), the 1993 National Environmental Women of Action Award for South Carolina presented by the National Wilderness Society, and the 1995 South Carolina Wildlife Federation Education Conservationist Award. Due to her environmental work in South Carolina she was in two national film documentaries, *Conserving America: The Rivers*, for efforts to preserve the Little Pee Dee River, and *When A Tree Falls*, for halting a highway through sensitive wetlands. Also for those achievements Hall was interviewed in the July 1995 issue of *Southern Living* and caused the environmental organization for which she volunteered to receive the coveted 1992 National Chevron Corporation Environmental Award.

Since returning to Florida, Hall has written for St. Augustine and DeLand newspapers, magazines, and placed second in two national writing contests. In 1999, Tailored Tours Publications published her first book, *Flavors of St. Augustine: An Historic Cookbook*. Her second, *Images of America: St. Augustine,* was published in 2002 by Arcadia Publishing. Her third, also published by Arcadia, is *Images of America: DeLand*. At present, she is working on a book addressing teachers' rights as citizens.

Hall is also a preservationist, having restored over two dozen historic properties in North and South Carolina and Florida. While living in St. Augustine and selling real estate she worked extensively with historic properties. After moving back to DeLand in 1999, she initiated a downtown residential revitalization project in a depressed area of over 100 architecturally significant buildings. *Southern Living* featured her Garden District project in its March 2004 issue. She also formed the Garden District Association and its Neighborhood Watch program.

Hall owns West Volusia Properties, a real estate firm. Her company began the first restoration award in the county, which presents quarterly a plaque and gifts to a family or business who has diligently worked to preserve a dilapidated structure. She sits on the City of DeLand's Code Enforcement Board and Strategic Planning Committee, the West Volusia Historical Society Board, and chairs the Design Committee for MainStreet DeLand. She is also president of the Central Florida Bungalow Association and Pen Women of West Volusia.

Hall is married to Ronald, also a Stetson graduate and now chair of Stetson's Philosophy Department. Their family includes two daughters and their husbands, four grandchildren, three dogs, and numerous grand animals.

INTRODUCTION

The word Stetson conjures up images of bucket-deep cowboy hats and dusty cattle drives, aromatic colognes and spiffy optical frames. But to the thousands who have passed through the hallowed halls of the oldest privately funded, continuously operated university in the state of Florida, the word Stetson ignites nostalgic visions of hard work and fierce pride.

In 1881, Florida's Superintendent of Public Instruction bemoaned the fact that although there were thousands of parents who "desired to educate their children," institutions of higher education in the state were limited. However, due to the single-handed efforts of one man, Henry A. DeLand, a New Yorker who relocated to Central Florida in 1876, Florida's educational plight was heeded and fresh seeds of scholarly thought planted deep within a piney forest in a state with a population of only 300,000.

Having its origins as DeLand Academy, founded in 1883 by Henry A. DeLand, it was renamed DeLand College in 1885, then DeLand University in 1887. By 1889, the school was given a new name, this time John B. Stetson University. Then in 1951 the enduring title that carried the school forward into a new millennium was officially changed to Stetson University.

Located in DeLand, approximately 30 miles north of the burgeoning metropolis of Orlando, Stetson's main campus exudes tranquility, welcoming the studious young adult as well as the casual stroller. Canopied by exalted live oaks whose limbs drip with Spanish moss, visitors passing through this quaint town are drawn to Stetson's elegantly aging buildings, beckoning the observer to step back into a time when life was less harried.

And indeed in the year 1876 the pace of life was leisurely, undeveloped land plentiful, and the new frontier, Florida, alluring to an adventurous entrepreneur such as Henry DeLand. Enchanted with the natural charm of the area and with the addition of more settlers, DeLand sought to create a town which others soon named in his honor. Henry DeLand's generosity and leadership generated a community which thrived on orange groves, hospitality, and tourism. A church, the First Baptist, a fire department, and a small school rose from the fertile fields of this outpost of civilization.

Then on November 5, 1883, Mr. DeLand's dream, DeLand Academy, came to fruition when 13 students began classes in the Baptist church. But Mr. DeLand, ever looking to the future and realizing that additional space would soon be required for the inevitable influx of students, immediately initiated construction on the academy's first building. By October 13, 1884, 88 students walked through the doors of the newly completed DeLand Hall, a Second Empire frame structure that today proudly bears historic recognition as the oldest building of higher education in continuous use in Florida.

Serendipitously, just prior to the opening of DeLand Academy, the Florida Baptist Convention was also considering establishing a college "on which to lavish affection and gifts." For years the idea had been parlayed about among members of the convention's board until finally in 1884 a motion was passed to "take immediate steps" to establish a "Female College for our State." The committee appointed to locate a proper site selected the Gainesville area, but Henry DeLand, as always one step ahead of his time, offered the Baptist Convention land, personal funds, and DeLand Academy for its new college.

On December 13, 1885, the Florida Baptist Convention accepted the "generous offer of Brother DeLand," and thus cooperation between a benevolent entrepreneur and a religious denomination gave birth to what is today the outstanding educational facility we have in Stetson University. Although no longer affiliated with the Florida Baptist Convention, Stetson maintains its enduring motto, Pro Deo et Veritate—For God and Truth, a motto that

exemplifies an essential ideal: Belief in the existence of a Supreme Being does not negate one's unrelenting quest for truth.

Indeed, the cornerstone for this intellectual pursuit was laid by Stetson's first president, Dr. John F. Forbes, a New York professor, when he said that the college must " . . . [D]evelop . . . in the student the habit of independent judgment...investigating statements and principles . . . discover[ing] . . . truth . . ."

However Forbes' most impressive principle relied on the importance of good teachers. As he so often expounded, "Buildings, libraries and apparatus are good and give added power, but the vital contact of students with a vigorous and stimulating mind and heart--this is the sine qua non of a successful education—[finding] men and women of large heart and mind . . . full of enthusiasm and stimulating power."

This concept of "large heart and mind," of teaching with an enthusiasm that electrifies and stimulates the student, is at the very core of Stetson University's philosophy, a viewpoint vigorously pursued by its president since 1987, Dr. H. Douglas Lee, or "Doug" to both faculty and students.

Although DeLand College grew in reputation and size under the tutelage of Dr. Forbes, the school was constantly in need of funds. With the demise of Henry A. DeLand's wealth through various land speculation losses and a devastating freeze in 1886 that destroyed local citrus crops, Mr. DeLand bid farewell to his beloved Southern state, returning home to New York. Fortunately for the school, though, a new benefactor, encouraged by Mr. DeLand, appeared on the horizon—John B. Stetson. Elected to DeLand University's Board of Trustees in 1887, Mr. Stetson quickly gained the admiration of the board and by 1889 was appointed board president.

A man with no formal education yet a success in the hat business, Mr. Stetson desired to strengthen the college both academically and financially. His diligence and leadership brought forth a surprise response from the trustees as they voted, against his will, to rename the school in his honor.

In 1900 the first college of law in the state of Florida was founded on the campus at John B. Stetson University. It eventually relocated in 1954 from the DeLand campus to Gulfport. Today Stetson's Law School is nationally ranked, its graduates regularly bringing distinction to their alma mater.

A few years into the 20th century found Henry A. DeLand's humble seeds planted in 1883 sprouting to include half a dozen architecturally notable buildings still in existence today, including Stetson Hall (1886), Florida's oldest college dormitory and possibly the first coed dorm in the state, and Elizabeth Hall (1892), now the repository for a Beckerath organ, the first of its kind installed in an American university. In fact, Stetson's campus was designated in 1991 as a national historic district because it contains the oldest collection of educational facilities in the state of Florida.

As we move deeper into the 21st century, Stetson University continues to contribute significantly to the educational needs of the zealous students who fill its classrooms seeking to capture the rhythm of their teachers' heartbeat. Enthusiastic and dedicated faculty members guide inquiring minds toward a better understanding of who they are in relation to the complexities of the cosmos by promoting critical analysis of mankind's responsibility toward humanity as well as mankind's responsibility toward nature. As Stetson's professors challenge their students, setting high standards of achievement, they fulfill the long ago task Stetson's first president, Dr. Forbes, set for the school: " . . . [D]evelop . . . in the student the habit of independent judgment"

And as the voices of Stetson's students, past and present, chant the majestic strain of their Alma Mater, may they remember those who built their institution and forever cherish the anthem's promise: "Dear Alma Mater, smile upon thy children . . ." as it has for over 100 years and surely will continue to do in the years ahead.

One

HISTORIC PAST
1883–1947

Abundant timber, freshwater springs, wildlife, and productive soil brought homesteaders to Central Florida's vast uninhabited terrain. Although small communities sprouted like weeds along the main waterways surrounding present-day DeLand, the area originally known as Persimmon Hollow remained unsettled for decades after the United States purchased Florida in 1821. Legend has it that the little hollow east of the big river was so laden with wild persimmons that it drew an abundance of foraging game, especially quail and deer. In turn such a plentiful source of game provided a popular and productive hunting ground for early Native Americans as well as arriving settlers.

The year 1874 brought the first pioneer to the area, John Rich, a decorated Union captain, who was not afraid of adventure or laborious work. Accompanied by his wife, Clara Wright, Rich filed his homestead, cleared his newly acquired land, built a cabin, and planted crops. Several other spirited pioneers joined the Rich family including Cyrenius Wright, Clara's brother, J.S. Craig, and O.P. Terry.

Persimmon Hollow's name change took place after the generous donation of acreage for a school, church, and main thoroughfare by Henry Addison DeLand, a wealthy entrepreneur from Fairport, New York. Mr. DeLand first visited the carved-out little hollow of a community with his brother-in-law, O.P. Terry, who had purchased property to raise oranges. Mr. Terry, impressed with the favorable agricultural opportunities, encouraged DeLand to accompany him on a trip south.

March 1876 found the men traveling by rail to Jacksonville, then a steamboat up the St. Johns to Enterprise, and finally a rig to the hollow. Mr. DeLand was unenthusiastic during his bumpy ride from Enterprise but as the flat terrain transitioned from swamp to rolling acreage, it was reported that Mr. DeLand exclaimed, "This looks like the West. Here is snap and push. I am willing to go on." And so he did.

History does not indicate whether Mr. DeLand was more impressed with Clara Rich's fried chicken or the verdant orange groves planted by the settlers, but whatever it was, Henry DeLand was hooked. He proclaimed that he could "see for great distances through the tall pine trees." Within hours of rolling into Persimmon Hollow, Henry DeLand was the satisfied owner of 159 acres located between present-day New York and University Avenues and extending east from present-day Clara to Amelia Avenues.

In October 1876, Mr. DeLand returned to Persimmon Hollow to assist in the establishment of the town. During the meeting Mrs. H.B. (Hettie) Austin announced that she was collecting money to build a church. Mr. DeLand, a practical man who believed education was the cornerstone of a strong town suggested, "Build a schoolhouse and use that for a place of worship as well as a school. If you wish to locate on land I have bought, I will give an acre." He also donated funds to cover half the cost of construction.

So impressed with Mr. DeLand's future plans, the "Athens of Florida" he promised the town would become, the settlers voted two months later to rename their community DeLand in honor of the man whose vision for growth and fervor for citrus production were captured in the hearts of many.

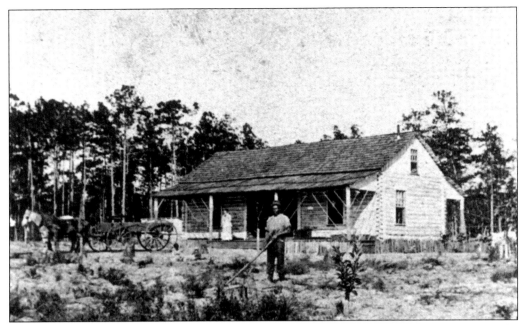

The Rich family's pole cabin was constructed in 1875 from long-leaf pine, a once plentiful natural commodity in DeLand. A plaque now designates the cabin's original location at the corner of Delaware and West New York Avenues. It was in this home that Henry DeLand stayed when he first visited Persimmon Hollow. One could say that had Mr. Rich and his family not moved to the Hollow, Stetson University would not exist.

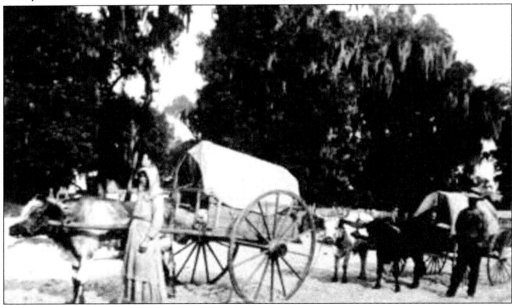

Within months, land was cleared for additional streets, while dirt lanes were renamed for early settlers: Amelia Avenue was named for Amelia Leete, Henry DeLand's sister; Clara Avenue for Captain Rich's wife; and Rich Avenue for the first pioneer family. During this exciting time, many more families arrived in town to begin a new life in the Florida frontier.

Henry Addison DeLand, of Fairport, New York—founder of the city of DeLand and DeLand Academy, the forerunner of Stetson University—was a philanthropist with vision and heart. Early in life, he decided that if he became a financial success, he would donate a portion of his money toward a worthwhile project. DeLand kept his promise, donating thousands of dollars to develop Persimmon Hollow into the "Athens of Florida." His zeal for creating a progressive town and educational center caused the evolution of a small frame school in the piney woods of Central Florida to become one of the most outstanding private educational institutions in the United States. Henry A. DeLand deserved to have a town named after him just as he deserves to be appreciated for his generous gifts of time, energy, and financial support. The last 32 years of his life he gave to his adopted town. He remained an honorary trustee of Stetson University until his death, and he was the honorary life president of the Old Settlers Society. When asked how he happened upon the area, he reported that he wanted to "find a delightful home when the blasts of winter were on." He found what he was looking for in Persimmon Hollow, Florida.

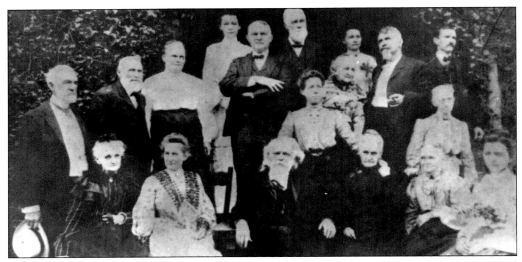

The Old Settler's Society, originally known as "Pioneers of DeLand and Vicinity," required that in order to be a member one had to have homesteaded property prior to 1877. Pictured standing are S.W. Walts, J.J. Vinzant, Mrs. J.J. Vinzant, Mrs. G.A. Dreka, G.A. Dreka, E.W. Bond, Mrs. C.O. Codrington, Rudolph Fran, and C.O. Codrington. Seated are Mrs. L.A. Fudger, Mrs. S.W. Walts, Henry A. DeLand, Mrs. C.A. Miller, Mrs. R. Franck, Mrs. Clara F. Rich, Mrs. C.C. Codrington, Mrs. O.J. Hill, and Miss Helen P. DeLand. During a community meeting Henry DeLand encouraged his friends to build a school. In a letter written by Henry Austin to his sister in Indiana, he boasted, "We will . . . have a good schoolhouse . . . in a few weeks."

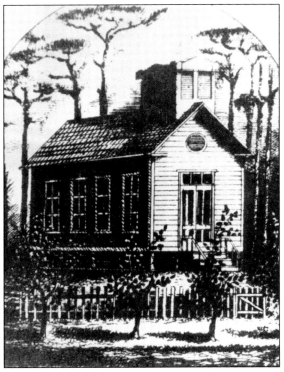

In March 1877, the school was ready. Cosner and Bloomer designed the elaborate building, quite grand for such a small community. But then the town was to be an outstanding leader in education for Florida. The one-room schoolhouse had a large bell tower. For practical purposes the building faced south to take advantage of cross breezes from the Atlantic to the Gulf. Four tall six-paned windows on each side captured the air flow. No expense was spared yet students were required to supply their own chairs and tables, often simple pine boxes. Located on the northeast corner of Indiana Avenue and Woodland Boulevard, the school was constructed of wide pine planks, the roof wood-shingled, and sat high off the ground to enhance cross ventilation. Citrus in the front, pine at the rear, and a picket fence completed a welcoming site.

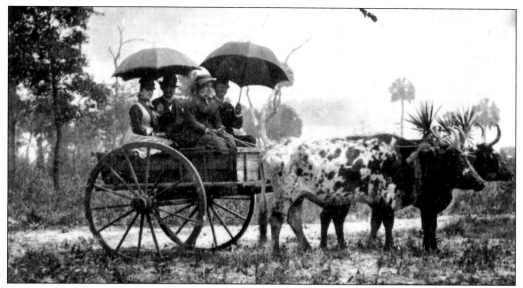

On May 7, 1877 double-front doors opened to the laughter or trepidation of students entering for their first day of class with Miss Rowena Dean of New York. The children were greeted with a sparsely furnished room, slate boards, chalk, a handful of books, and a hot four-month term before them. The first social event held at the school was in July 1877 when residents decided to reduce the mortgage on the schoolhouse by planning an ice-cream fund-raiser. Ten cents got a hungry participant inside, but in order to obtain a scoop of peach ice cream an additional sum was charged. Above, Miss Rowena Dean, DeLand's first teacher, enjoyed a sightseeing tour. Not only was Miss Dean able to rein in her students, she also seemed capable of reining in her oxen.

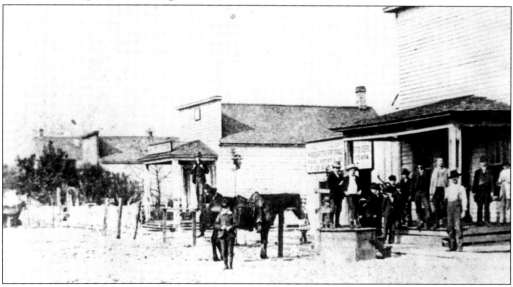

By 1882, new construction was rising along Woodland Boulevard and Indiana Avenue, the center of downtown DeLand. Amid dirt streets and frame buildings, men in formal work attire, and the ever-faithful mode of transportation prepare for another day under the hot Florida sun.

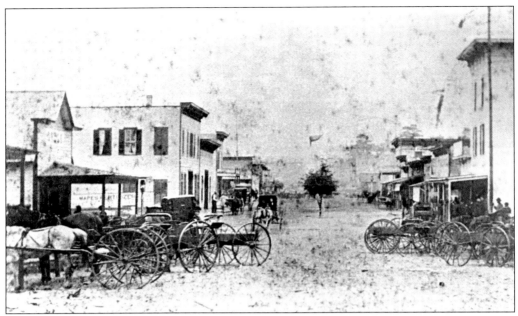

In the late 1880s, a Department of Immigration pamphlet listed the following for DeLand: three general stores, a drug store, a furniture store, a millinery, a post office with daily mail, phone service, several boarding houses, a church, a school, a livery stable, a newspaper, two sawmills, a wagon factory, a blacksmith shop, two physicians, two dentists, two lawyers, a library, and even a literary society. Indeed, DeLand was moving up. A year later, more frame structures were erected on both sides of Woodland Boulevard north from New York Avenue. Buggies brought customers to town for shopping and bartering. Per Henry DeLand's request, oak trees were planted in the median down Woodland Boulevard, later to be extensively damaged by horseback riders using the sapling trunks for hitching posts.

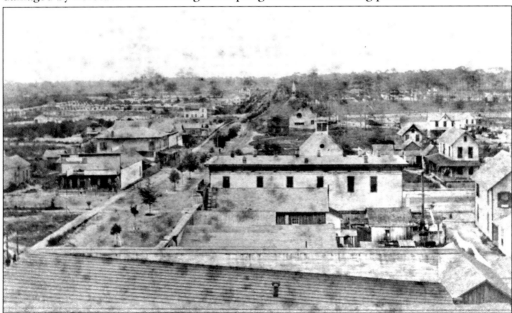

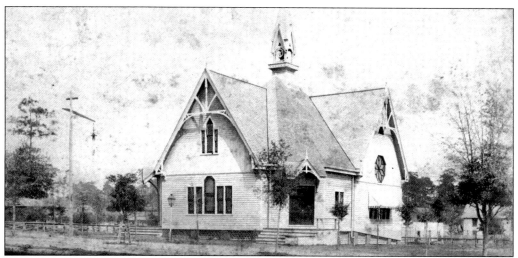

When the discussion arose for the need of a church, practical minded Henry DeLand suggested that church members meet in the new schoolhouse until they could raise funds to construct a building. Mrs. Parce, Henry DeLand's sister, proved the fund-raising project a success. She boasted in a letter to family members up north, "The ladies of the church gave an oyster supper last Thursday evening and after expenses, we find we have $86 left. Isn't that doing pretty well for a new country?" The first church organized was the Methodist Episcopal in August 1880. But the First Baptist Church, organized two months later with 13 members, was built first in 1881 on the southeast corner of Church Street and the Boulevard. Mr. DeLand, a Baptist, was a major donor.

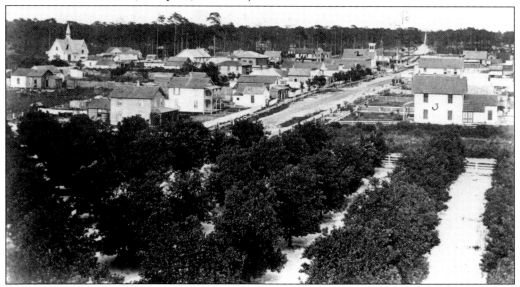

Toward the end of 1883 the quaint hamlet of DeLand stretched north, south, east, and west. The newly constructed Putnam Hotel was an excellent vantage point from which to view DeLand's expansion. By then the main road, Woodland Boulevard, was fronted by numerous businesses and stately frame homes. The newly constructed First Baptist Church is visible in the upper left-hand corner. Lush citrus groves, a major industry in DeLand, thrived downtown.

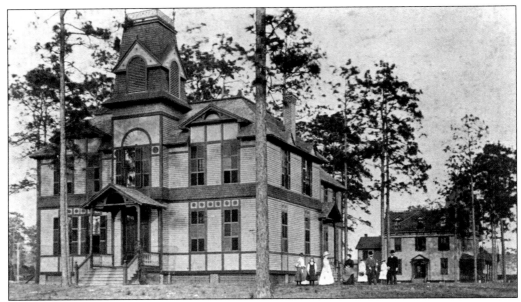

In 1883, Henry DeLand moved his town toward a more progressive educational agenda by founding DeLand Academy, the second educational institution in the city. It takes wisdom to seek the advice of others, and Henry DeLand had both wisdom and vision. He asked Col. C.O. Codrington, editor of the *Florida Agriculturist*, how to make their community more distinctive. The colonel's sage observation was that the town should become an outstanding educational center.

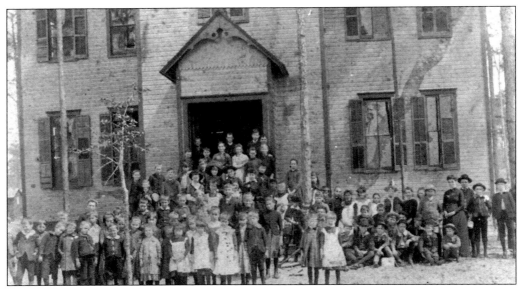

Since Florida had no four-year college, and there was strong interest in such an institution, in November 1883 Henry DeLand opened DeLand Academy to include advanced studies in preparation for college. Thirteen students met at First Baptist Church until Henry DeLand's two-story frame building was completed in 1884 at a cost of $6,000. The Academy was situated on four acres at the northeast corner of Woodland Boulevard and Minnesota Avenue.

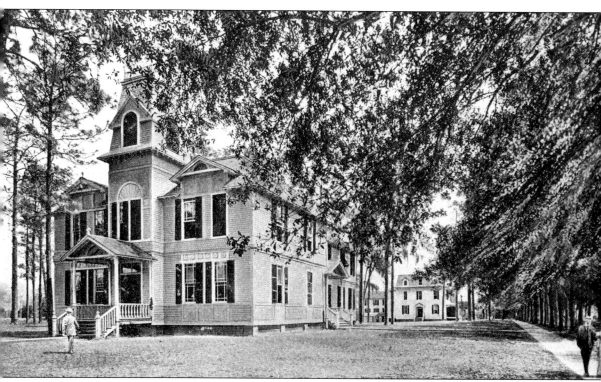

By October 1884, 88 students ranging in age from the very young to teenagers attended DeLand Academy. Classes included history, geography, physics, and physiology. Of course the younger ones continued to study "readin,' 'ritin,' and 'rithmetic." As Henry DeLand prepared to construct his academy, the Florida Baptist Convention was attempting to establish a female college. The convention promised that its college would be a place where "all forms of error, skepticism, and infidelity are to be met and refuted." While the convention vacillated between Gainesville and Lake Weir as the location for the school, decisive Mr. DeLand stepped forward to offer his academy for the college. DeLand's offer of $6,000 in cash, $5,000 in land, and an additional $4,000 from the town brought a unanimous acceptance in 1885 by the convention to accept his offer. There were eight classrooms in the main section, a chapel in the first floor wing, and a library on the second floor. It is the oldest academic building on campus and is listed on the National Register of Historic Places both as a part of the district and as the oldest building in Florida in continuous use for higher education. John P. Mace, Lake Helen's first mayor, designed DeLand Hall. This three-storied Second Empire building is considered to be one of the finest in Florida.

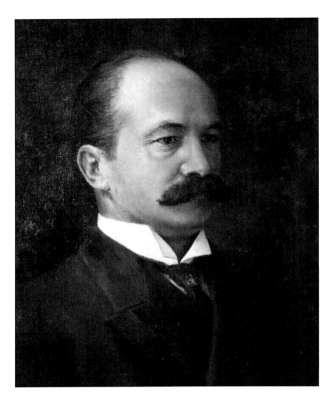

In 1885, DeLand Academy became DeLand Academy and College. At 32, Dr. John Franklin Forbes became the school's first president. In 1887, the name was changed to DeLand College and University. Dr. Forbes, a scholar of Greek and psychology, was known for his pedagogical skills and continued to teach while at the university. Dr. Forbes was admired by both faculty and students and was noted for his financial contributions to the school, to area churches, and, most importantly, to needy students.

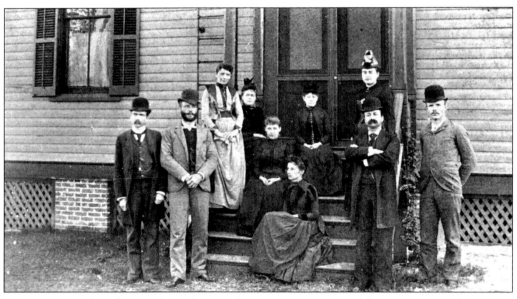

The average salary for teachers during these early years was $40 per month plus room, board, and washing. It was said of President Forbes that "he had a rare ability in judging human personality and worth, and that this enabled him to collect an able faculty and to be a successful teacher and president." Dr. Forbes stated in a report to the board of trustees that "Some have gone whom we wanted to stay, but none have stayed whom we wanted to go."

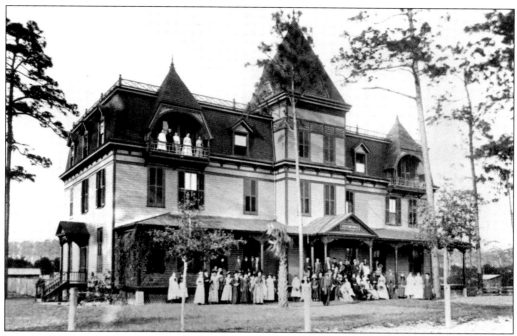

Stetson Hall, completed in 1886, was the school's first dormitory. Mr. Mace, architect for DeLand Hall, again chose the Second Empire style. John B. Stetson donated $3,500 toward the $12,000 project. The spacious first floor had a reception area, music rooms, dining room, kitchen, and a private five-room suite for President Forbes and his family. Students and teachers were housed in large, well-furnished rooms on the second and third floors, men and women separated by a strong partition. The dormitory was equipped with running water, bathrooms, electricity, and steam heat.

In 1887, the Florida Legislature granted the charter to DeLand University, defining a self-perpetuating board of trustees to be three-fourths Baptists with the president also to be a Baptist. Thus Stetson's future as a Baptist educational institution was established. As the school grew so did the town's religious needs. Eventually the little frame Baptist church, where DeLand students first took to the books before DeLand Academy was built, sold its building to the Methodists. The Methodists moved the structure 200 feet east of Woodland to the north side of Rich Avenue. Thanks to a generous donation from John B. Stetson, the First Baptist Church built this 1895 red-brick Romanesque-style structure on the southeast corner of Church Street and the Boulevard.

After Henry DeLand's financial problems in the late 1880s rendered him unable to support the university, he turned to prominent Philadelphia hat manufacturer John Batterson Stetson for assistance. Mr. Stetson had built a winter home west of DeLand and was one of the largest citrus growers in the area. In 1887, he was elected to its board of trustees. In 1889, with the encouragement of Henry DeLand and President Forbes, the name of the institution was changed to John B. Stetson University.

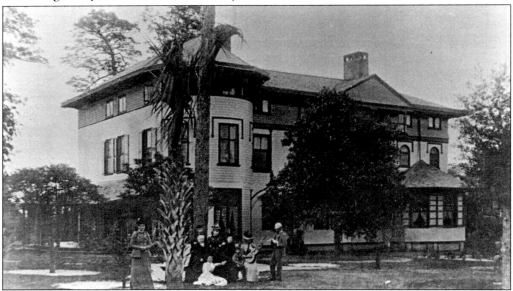

Mr. Stetson purchased over 300 acres west of town, then ordered workmen to craft him a grand winter residence of 7,500 square feet. He remained a seasonal resident for almost two decades, improving citrus production in the city while donating generously to the university. Mr. Stetson even had an alligator pond built at the back of the house to hold his exotic pets. The home is privately owned and has been magnificently restored.

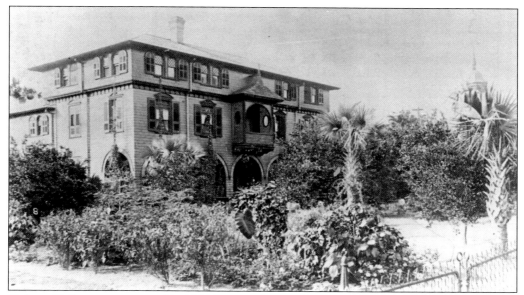
Holmes Hall was constructed in 1890 for President Forbes as well as future college presidents. The architect, Mr. Clake, also remodeled the Hotel College Arms for Mr. Stetson. Elizabeth Hall's cupola is seen at the far right. The new home contained a large living and dining room, 10 bedrooms, and numerous fireplaces.

In 1892, Chaudoin Hall—named for W.N. Chaudoin, a Stetson trustee from 1886 until 1904—opened its doors to women only.

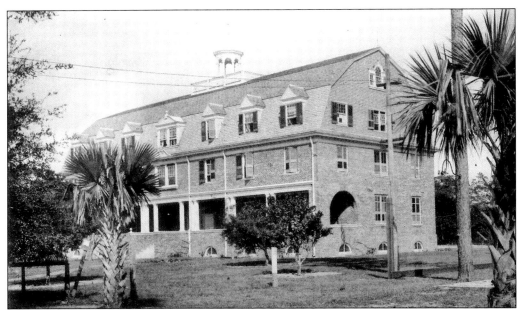

The north wing of Chaudoin Hall was constructed in 1892, the south wing in 1935. This three-story Colonial Revival gem has characteristic features such as a small cupola with balustrade crowns on the gambrel roof, multiple dormers, and Palladian leadedglass windows at each end. The name given DeLand's main street, Woodland Boulevard, vividly describes what Henry DeLand created with his water-oak plantings that front the campus. The tall pines south of Chaudoin were all that remained of the once pine-forested center of town.

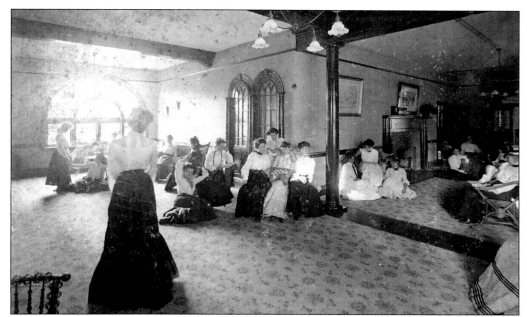

Chaudoin's interior contained a kitchen and dining facilities, several parlors—one with a fireplace—comfortable furniture, and eventually a rosewood piano belonging to John B. Stetson. Students resided on the second and third levels, reached by an elegant staircase. Although the building was handsomely furnished, there seemed to be a shortage of bathtubs, as evidenced by a 1907 check for $50 from a generous donor who designated the money be used to purchase hygienic items. In 1920, the price for boarding at Chaudoin was raised from $20 per month to $32. Students were unhappy with the increase, as they considered the food unpalatable.

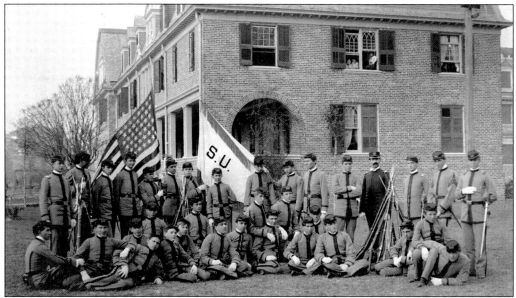

The grounds on Chaudoin Hall's south side were used for military drills while attentive coeds cast longing glances from their dormitory window.

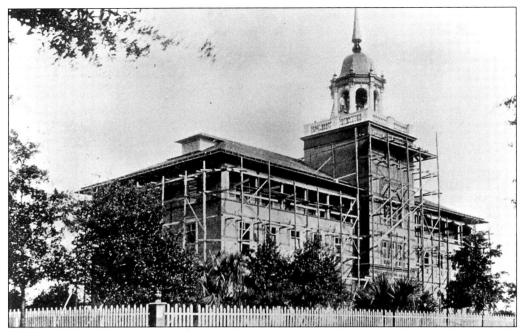

As student enrollment increased so did the need for additional academic space as 1892 saw yet another Colonial Revival construction on campus with the completion of Elizabeth Hall. The building was partially funded with a donation of $45,000 from John B. Stetson and named in memory of his third wife, Elizabeth Shindler Stetson. President Forbes said of this latest project that he desired "the finest building for educational purposes south of Washington." He designed the size and use of each room, requiring that it be wired for electricity, a first for the campus. Total construction costs reached $125,000, more than the combined cost of all other Florida school buildings of higher education at that time.

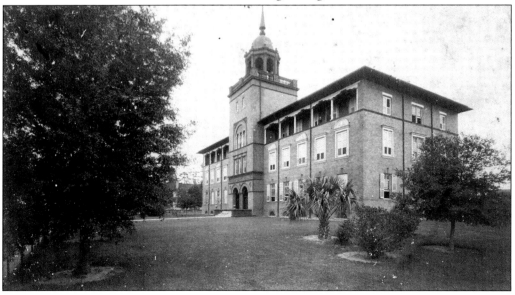

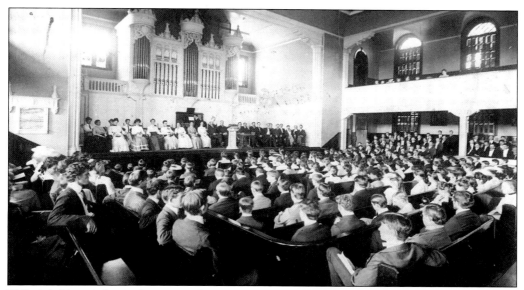

Philadelphians John B. Stetson and George T. Pearson, Elizabeth Hall's architect, decided to give the campus a smaller version of their city's Independence Hall. Elizabeth Hall received north and south wings in 1897. The south wing of Elizabeth Hall housed the chapel where assemblies, worship services, and graduation exercises were held. The chapel is dedicated to the memory of Ben, one of Mr. Stetson's sons, who died at the age of six.

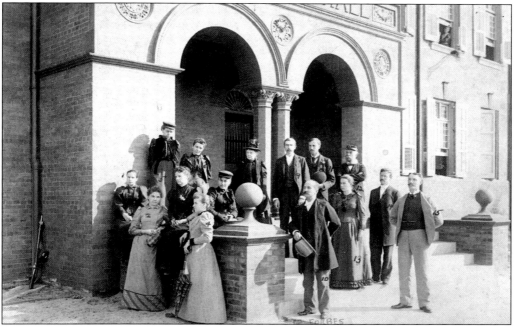

Elizabeth Hall's tower originally held a water tank used to supply the campus. Sometime around 1915, the water tank was removed when the City of DeLand supplied water to the campus. Bell chimes were then placed in the tower to remind students of the hour and special activities. The north wing was used for faculty and staff. President Forbes gathered his staff outside for a photo that outlived them all. He is leaning against the pillar.

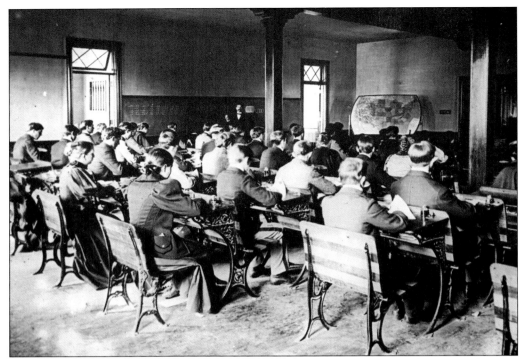

By the late 1890s, classes ranging from Greek and Latin to mathematics, history, literature, and the natural sciences were offered. Even penmanship and woodworking classes were taught.

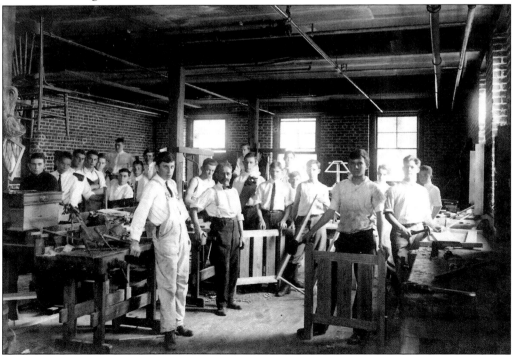

Stetson students diligently studied the banking industry in their business class, pictured in Elizabeth Hall.

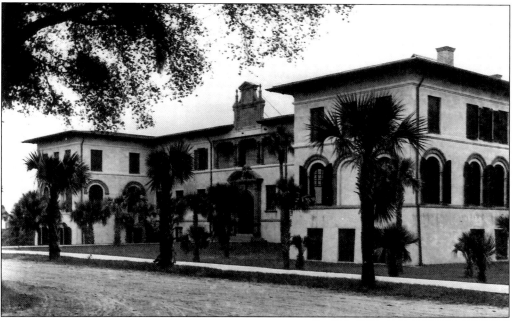
Stetson expanded with yet another academic building completed in 1902. Flagler Hall—originally Science Hall—was the first campus building constructed on the west side of Woodland Boulevard and directly across from Elizabeth Hall. The property was purchased by Mr. and Mrs. Stetson from J.F. Allen and then donated to the school. The architect was William Charles Hays, who wanted the building to be worthy of its benefactor, Henry Morrison Flagler, the Standard Oil magnate and developer of Florida's East Coast.

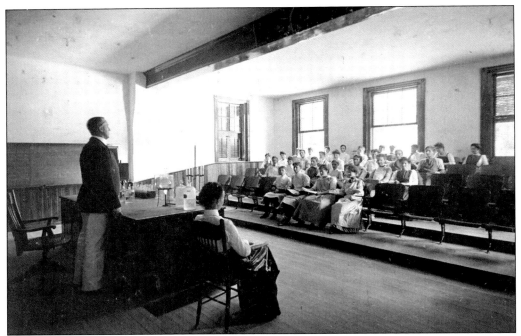

Flagler stipulated the building not be named after him during his lifetime as he feared other schools would request donations. After his death in 1913, the name was changed to Flagler Hall in honor of the railroad magnate's contribution to higher education. Flagler Hall, originally to have only two floors, was increased to three when it was discovered that due to the westward-sloping terrain the first floor would be several feet beneath grade and thus dominated by Elizabeth Hall.

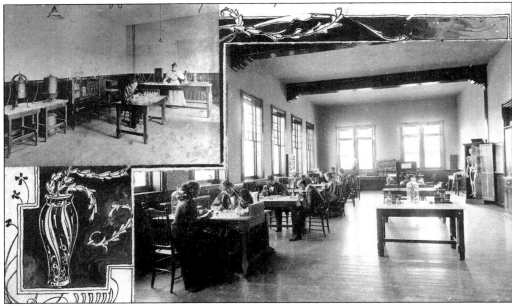

Biology classes in Flagler were offered under the keen supervision of a human skeleton hanging silently in the back of the room, keeping a watchful eye over the students.

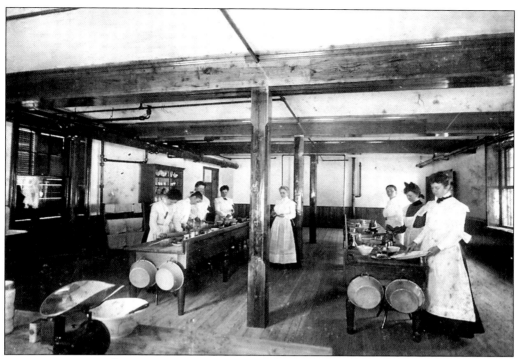
Home Economics classes were taught to both female and male students and included such necessities as learning how to wash clothes in a galvanized pail, measure flour, and properly bake goodies. White starched aprons add to the primness of the college course.

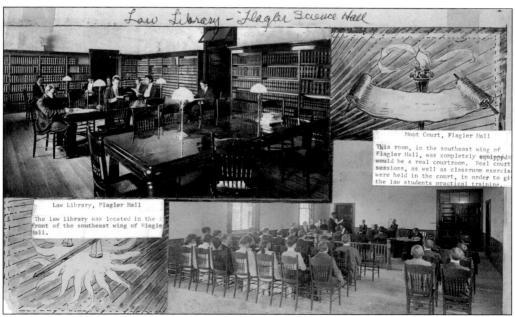
More serious studies occurred in law, with Stetson establishing Florida's first Law School in 1900. Located in Flagler Hall, the classes were predominantly filled with men.

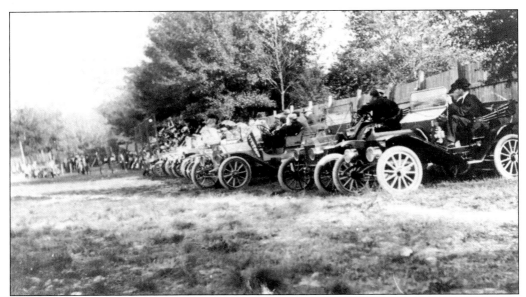

Stetson's football team brought out the crowd when the men played on the west side of Woodland Boulevard, across from Chaudoin Hall. The turf was mostly weeds and sand, but no one cared. Bleachers were few, crowded, and uncomfortable, but no one cared. After all, Henry Ford's newest invention served quite nicely for a comfy seat to watch Stetson beat its rivals. The first organized football game in Florida was held at Stetson on Thanksgiving Day 1894. Fans, arriving by horseback or on foot, paid 25¢ admission. Stetson claimed championships in 1901 and 1903.

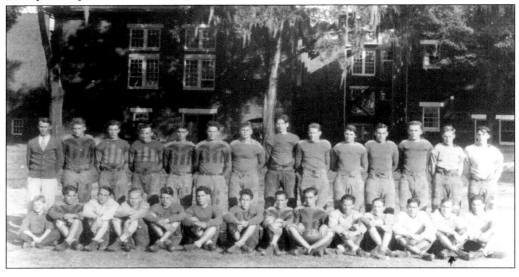

The school encouraged exercise for all students, including children attending its academy, which operated until 1925. Chaudoin Hall is seen in the background.

The school's first gym, 100 feet by 40 feet, was constructed in 1891 with funds from John B. Stetson. It was used as an auditorium until Elizabeth Hall's south wing was added. This 1891 photo shows a segregated class preparing for calisthenics.

In 1904, Dr. Lincoln Hulley, age 39, became the university's second president. He had a flamboyant personality, was enthusiastic, a hard worker, and possessed a keen ability to deal with financial problems. He also encouraged Mr. Stetson to renew his contributions to the school. Dr. Hulley asserted that "Stetson University was planted by God and that God never would let it fail if the persons responsible for its operation would attend well their duties." Dr. Hulley followed his beliefs by attending well to his duties as the university's new Baptist president. He claimed to "work twelve hours a day, seven days a week." He promised the Board of Trustees that he would carry out his responsibilities to the university "in the fear of God, and not in the fear of man." He was a hands-on president, supervising everything from janitorial services to student scholarships.

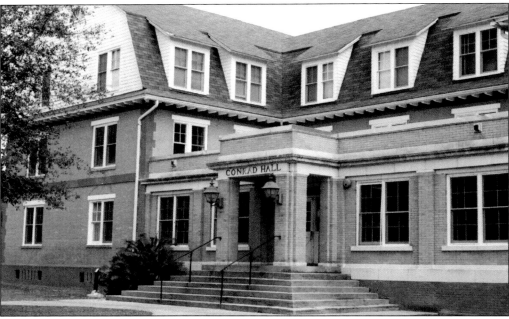

The original Conrad Hall, named for Jacob B. Conrad, a university trustee and lumberman who owned a large sawmill near Glenwood, was built in 1901. It burned in 1903 and was rebuilt in 1909 on a smaller scale. It was intended for ministerial students who could afford only to pay the minimum amount for room and board. Conrad is an H-shaped, Dutch Colonial Revival building with gambrel roof and carved rafter ends. The exterior is buff sandstone brick.

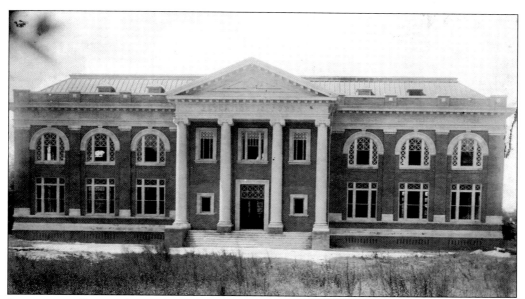

Sampson Hall, completed in 1908 in the Neoclassical style, is considered one of the most architecturally significant buildings on campus. It was designed by Jacksonville architect James Klutho, who pioneered modern American architectural design in Florida. Identified with the Prairie School of architecture, Klutho was closely associated with Frank Lloyd Wright. He holds the distinct honor of being the first Floridian to become a member of the prestigious American Institute of Architects.

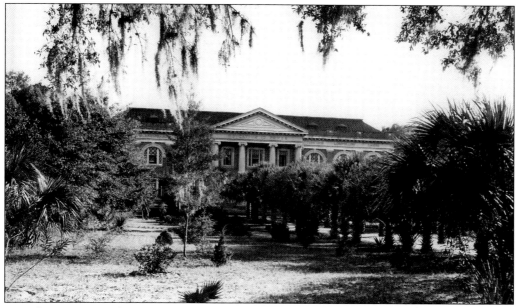

Over the entrance is a bronze bas relief of Henry DeLand crafted in 1909 by Count Santa de Eulalia, a Portuguese nobleman and sculptor who was Mrs. Elizabeth Stetson's second husband. Mrs. Stetson funded an endowment to match $40,000 from Andrew Carnegie. Mr. Sampson, a school trustee, gave $1,000 to establish the library, $1,000 annually, and $20,000 at his death. The palm court in front was planted in 1909.

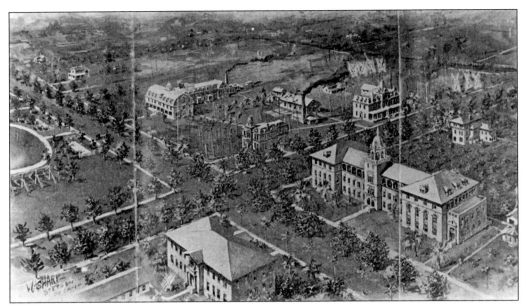

At the time of Henry DeLand's death in 1908, his dream to make DeLand an educational center had been realized. By then, the university had nine architecturally significant buildings, including three dormitories, a library, an enrollment of 233, and an income-producing endowment of over $225,000. This early 1900 lithograph shows Stetson's sprawling campus with Henry DeLand's 189 water oaks dividing Woodland Boulevard.

Cummings Gym, completed in 1911, was designed by faculty member Litchfield Colton at a cost of $12,000. J. Howell Cummings, president of the Stetson Hat Company in Philadelphia, contributed $6,000. Cummings was the second gymnasium built for the university. The first, a small wooden structure, was the first gymnasium in Florida. Cummings was the second building constructed on the west side of Woodland Boulevard. Carl Turnquist, Stetson's woodworking department head, supervised construction.

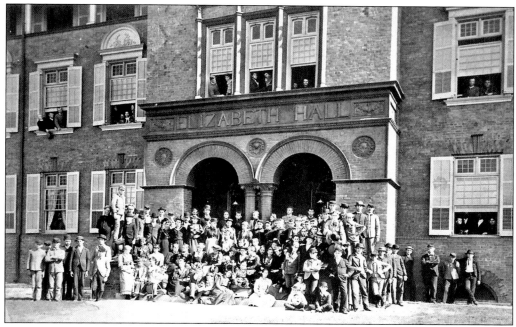

One might get the impression that these sedate poses depict the behavior of the students. However, history has a different perspective, as reported by President Hulley to the board of trustees in 1925. He noted that when Stetson graduates returned to campus they "liked to regale the students with stories of their own mad capers . . . and the young students felt compelled to go them one better." A former student from the early 1900s even admitted such audacious acts as painting stripes on the president's horse and stringing toilet paper in the trees along Woodland Boulevard.

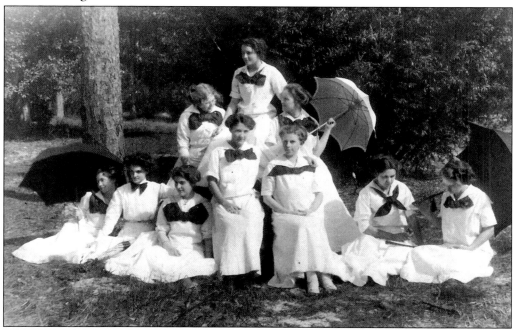

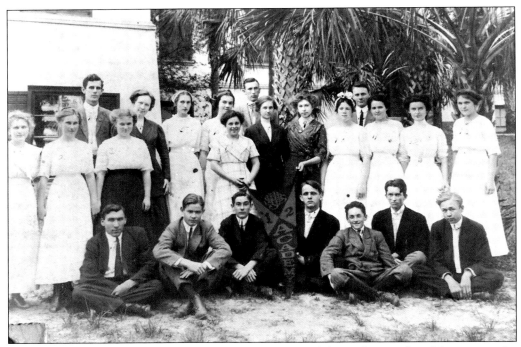
With all the building that was taking place, Stetson did not lose sight of its reason for existence—educating students. Fulfilling their academic responsibilities, DeLand Academy's class of 1912 proudly graduates.

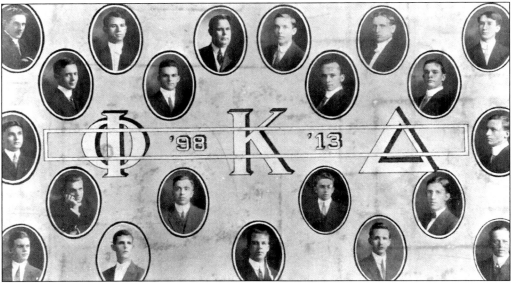
Student life included fraternities and sororities, literary and oratorical societies, and a chess club. Both men and women took advantage of these extracurricular activities.

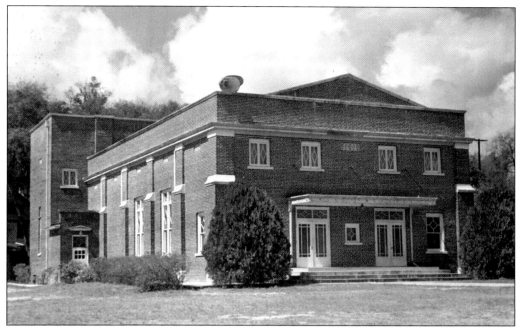

Construction on campus ceased until 1930, when Stover Theatre was built. Still used for theatrical productions, it houses the South's oldest collegiate acting company. Originally called Assembly Hall, it was renamed in 1938 for Stetson's revered professor of speech and theatre, Irving Stover. Assembly Hall was dedicated in November 1930 and opened with *Apollo and the Muses*, written by President Hulley. Some believed that Hulley wanted a theatre for the sole purpose of performing his plays. There also was consternation from the Baptist Convention. Hulley appeased members by acknowledging that theatre had encouraged "filthy language . . . dirty plots and . . . sex exploitation," but promised Stover Theatre would not tolerate such vulgarities.

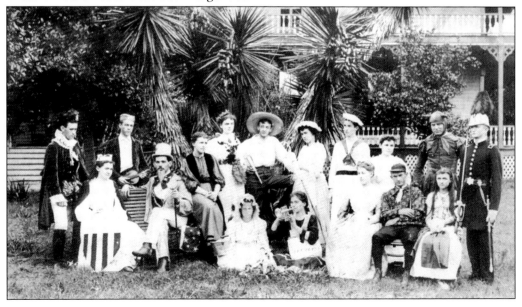

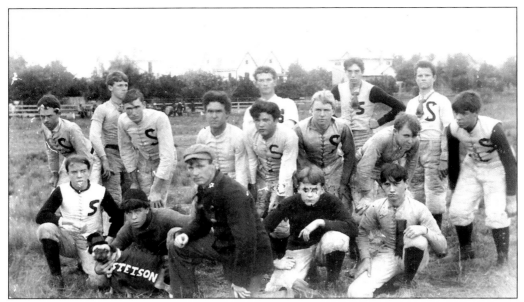

Stetson's baseball team has been a winner since its early days, with five baseball players heading to professional leagues as early as 1916. This 1895 ready-to-play team was coached by James Campbell Ford McInnes, Stetson's Greek and Latin professor. The university and the town took baseball seriously, as did the Conrad family. In 1932, the Conrads donated to Stetson land south of downtown along Woodland Boulevard and Alabama Avenue for development as a baseball field. That same year, the team was given yet another home run with the hiring of Carl H. "Doc" Johnson.

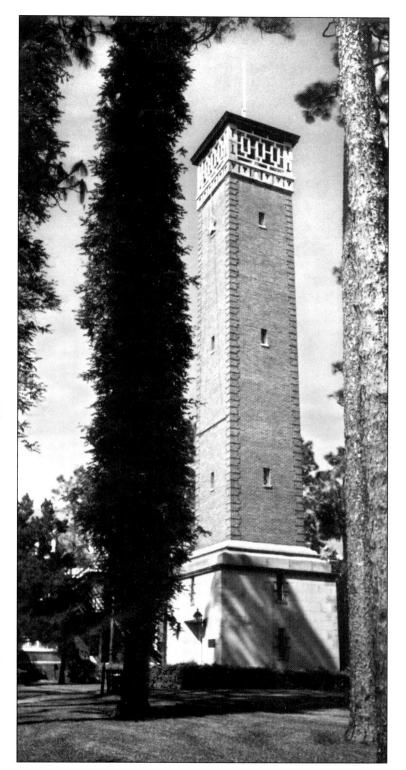

Hulley Tower, completed in 1934, is 116 feet high. Stetson math professor Curtis M. Lowery designed and engineered the project. Dr. Hulley died in January 1934 just prior to the completion of his project. The tall pines surrounding the tower are the only survivors of what was once described as "a hill of wonderful pines" when Henry DeLand began his Academy in 1883. DeLand Hall, as it was named, is situated south and adjacent to Hulley Tower. Chaudoin Hall is directly north of the tower.

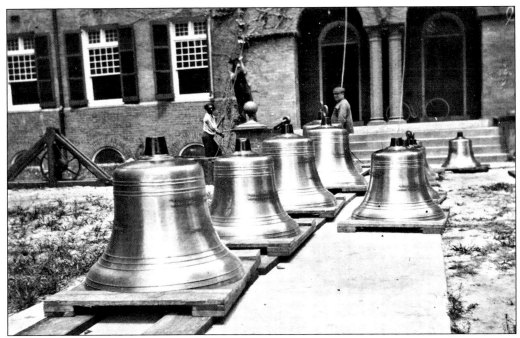

Four large and seven small bells in Elizabeth Hall's cupola, ranging from 575 to 3,000 pounds, were removed in 1915 due to structural damage caused by their resonating sounds. When Hulley Tower was completed, the carillon was taken from storage, cleaned, polished, named in honor of Mrs. Hulley, and installed in Hulley Tower. This author had the privilege in 1963 of "pulling" the bells to serenade the students.

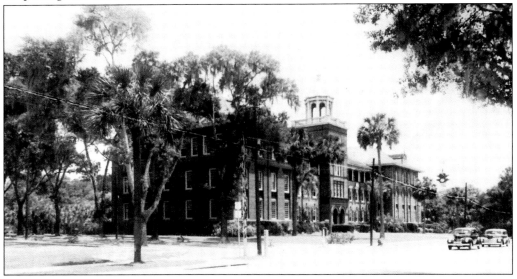

The development of Stetson's core campus was complete by 1934 under the leadership of President Hulley, with 10 structures completed by 1911. A variety of styles, including Colonial Revival, Neoclassical, Second Empire, and Masonry Vernacular, blend to make a rich and diverse display of architecturally significant buildings. The *American Architect and Building News* featured Chaudoin and Elizabeth Halls in its 1892 issue.

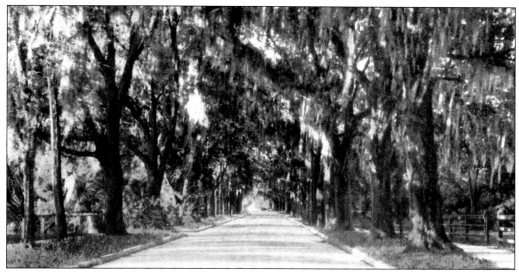

The campus and the town grew simultaneously, each enhancing the other as the "Town and Gown" tradition gained strength and momentum. This continuing phenomenon between Stetson University and DeLand has been vital from Stetson's establishment in 1883. Since the campus was adjacent to downtown, it afforded Stetson students the opportunity to shop and play within walking distance. A stroll to town along Woodland Boulevard was quite beautiful indeed, as it passed under Henry DeLand's growing oaks with their swaying Spanish moss.

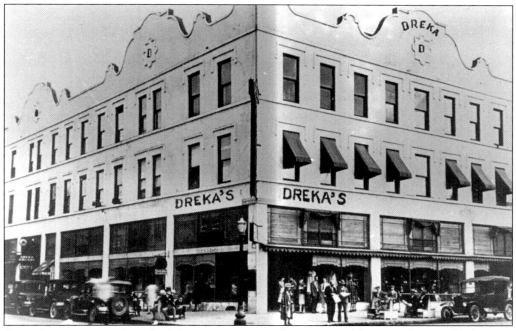

Once downtown, students had the opportunity to shop in one of the many fine establishments fronting Woodland Boulevard, including Dreka's, built in 1909. This one-stop department store offered clothing, furniture, and household goods. Three stories high, its architecture is classic Mission Revival.

Local merchants not only encouraged student business, they avidly supported the school, as evidenced by the store's wall decoration.

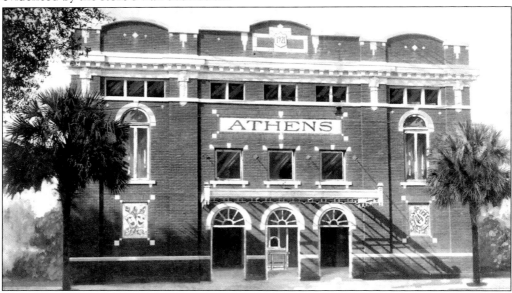
By 1921, the quality of motion pictures had improved to the point that investors saw the advantage of building deluxe theatres with both a stage for live shows and a screen for silent moving pictures. Two such theatres opened their doors in 1922—the Athens and Dreka Theatres. Touring performers entertained the audience with shows ranging from comedy to Shakespeare. President Hulley, reporting to Stetson's Board of Trustees in 1922 regarding student misbehavior, admitted, "The Dreka Theatre has complained, the grove men have complained, the temperance people have complained." He lamented, "Some parents have sent us incorrigible students."

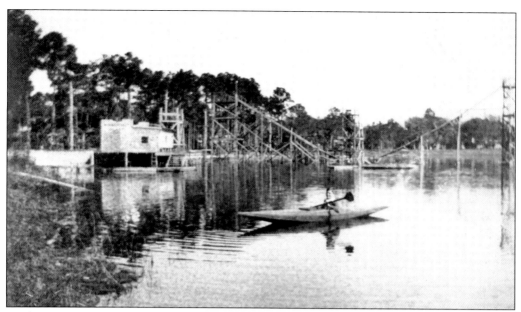

Students came to Stetson to attend an excellent educational institution; they also came for the balmy weather and natural environment. Outdoor activities were promoted from the school's earliest days. President Forbes so favored outdoor recreation that he helped build the beach and boating facilities at Blue Lake, a short distance up Minnesota Avenue from the campus. Sliding into the freshwater lake, canoeing its calm waters, and fishing were activities enjoyed by all.

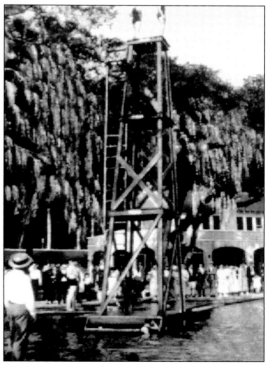

By 1905, DeLeon Springs, four miles north of the campus, offered a bathhouse and snack shop, a perfect retreat from demanding studies. DeLeon Springs had a 45-foot diving tower that hovered above the watery boil. Many a person braved the high altitude and chilly waters to give his or her friends a thrill. Nestled amongst graying Spanish moss and majestic live oaks, the spring was a favorite gathering place. The people in this 1930 crowd probably held their breath as the brave men got set to dive and only exhaled when the divers surfaced safe and sound.

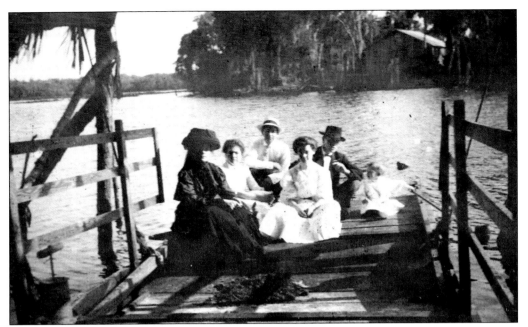

In the early, slow-paced, prim and proper days, there were tranquil ferry rides to Hontoon Island in Lake Beresford accompanied by family members or chaperones. Once across, visitors would enjoy relaxing picnics, trail hiking, and a climb up the ancient abandoned Native American shell mound.

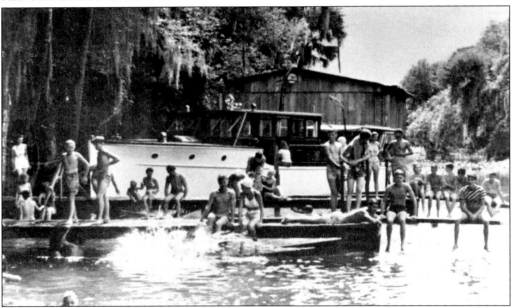

By the mid-1940s, times were changing on Stetson's campus, as with the rest of the world. Students were more active, less clothed, and definitely rejecting the idea of chaperones. They still continued to congregate on Lake Beresford and the St. Johns River, but their fun now included hanging out, dangling bare legs over the dock, and splashing about in the water with unrestrained gusto.

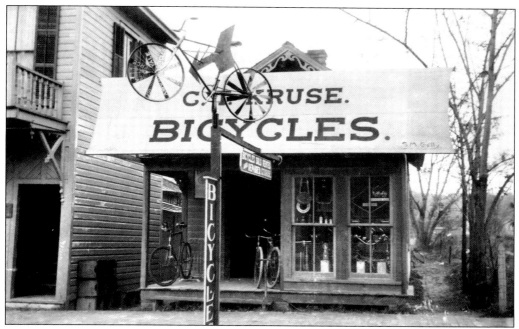

Mr. Kruse and his popular bike shop on Woodland Boulevard saw the change coming. So did Stetson administrators when they introduced regulations regarding Henry Ford's new horseless carriage. The once-popular sport of bike riding on trails between DeLand and DeLeon Springs was giving way to a faster pace as more students acquired wheels. And once they did, they were rolling east to Daytona Beach and the whitest sand and widest beach in the United States.

The automobile brought a freedom that earlier students had only dreamt of experiencing. Diners popped up to entice students away from campus food. When a coed enrolled at Stetson in 1931, her father, a physician, wrote requesting that she be allowed to eat away from campus. He explained that since she had injured herself as a child her "bones were soft and chalky," and that she must not eat starchy foods. The student was Etter Turner, who eventually became Stetson's dean of students.

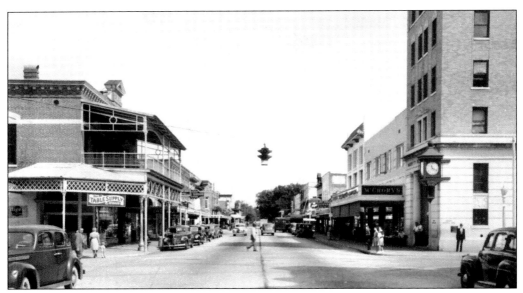

By the late 1890s, DeLand's streets were paved with crushed shells excavated from Timucuan Indian middens. In 1925, bricks covered the main roadways. By the 1940s, the bricks were removed to make way for concrete and even more cars. Gone were the slow-moving horse-and-buggy days; the age of the automobile and fast travel had roared into town.

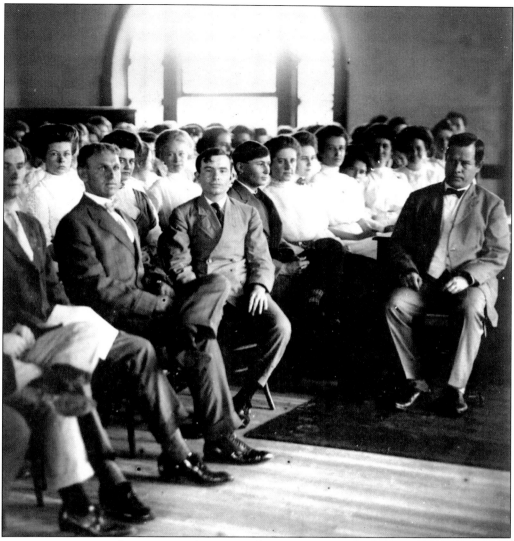

On January 20, 1934, Pres. Lincoln Hulley, far right, one of the most acclaimed orators in America, died unexpectedly. He had been at the helm for 30 years, leading the school with vigor and intellect. He led a successful building campaign and increased Stetson's endowment by almost $1 million. Enrollment increased from 201 in 1904 to 518 in 1934. He fought financial battles, and he fought battles with the Baptists. Always a charismatic speaker, his speech given in 1905 on the stage in Elizabeth Hall is described by Dr. Gilbert Lycan, Stetson historian and author, as "probably the most exquisite and literary statement of the University's ideals that has ever been given." From Dr. Hulley: "The ideals proper of this University are spiritual essences. They embrace all that is good and true and beautiful: honor and integrity in business, sincerity and candor in the social life . . . sanity and nobility of mind, serenity and simplicity of soul, sympathy and love for mankind, reverence for God and respect for self, joy and gladness in one's work . . . courage in the face of danger, strength in times of trial, gratitude for the love of one's neighbors" Hulley Tower soars high above campus as a tribute to his leadership and as the final resting place for both Hulley and his wife, Eloise.

Dr. William Sims Allen was 46 when he became Stetson's third president in 1934. He came from Baylor University in Texas where he was vice president and chairman of the School of Education. Dr. Allen's move to Stetson was applauded by the DeLand *Sun News* "as the greatest event of the year, presaging growth and improvements at Stetson." The first statewide radio broadcast for Florida carried Allen's first public address as Stetson's president. He increased religious classes from eight to sixteen, also adding Greek and translations. He created the Geology and Geography Department, and a Department of Library Science. Regarding his support of a Christian education Allen noted that a professor must "be a good scholar, an active Christian, a good teacher, have 'common sense,' and must be deeply interested in the young people."

Stetson Hall was one of the buildings Dr. Allen remodeled. In 1946 it was extensively modified and enlarged, causing most of the charm and character of this architecturally significant building to be lost. Gone were the balconies and pavilion. Extant are the mansard roof, gable dormers, patterned wood shingles, and molded cornices.

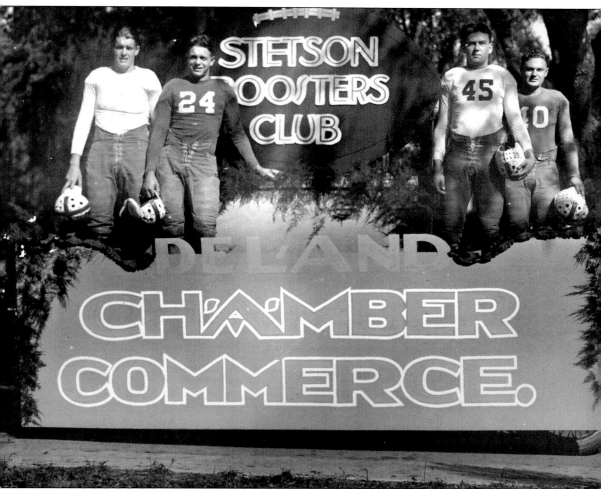

Football was always a popular sport on campus with its avid following by Stetson's students, faculty and staff, and DeLandites. The team had winning seasons in 1901, 1903, 1905–1907, and 1909. World War I caused a hiatus in campus football, but after the war ended students were back on the gridiron. During the war years, President Hulley was relieved that football was replaced with military drills. Although he confessed that he enjoyed viewing the sport, he resented the money spent on it. During one of Dr. Hulley's weaker moments when he vowed to discontinue football altogether, so adamant were DeLand residents and students that the games continue that they offered to pay all expenses involved in supporting the team. President Hulley allowed it twice but, as he admitted to Mr. Stetson, in his view "the results were calamitous." The most memorable football game was in 1938 when Stetson beat Florida 16-14. In 1941, when student enrollment dropped during World War II, President Allen announced that due to financial circumstances beyond his control the school would discontinue intercollegiate sports activities, meaning football. The *Sun News* described this shocking announcement as a "bombshell." Allen rationalized his action by stating that "emphasis on the sport was unseemly in view of the conditions of the country and the world." At war's end football resumed and with it DeLand's support of the game.

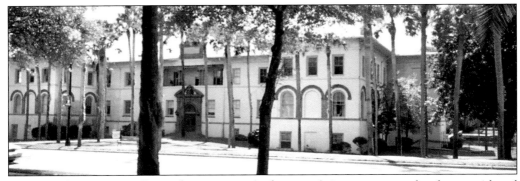

Dr. Allen found the College of Law in need of so much improvement that he considered closing it. Although it was American Bar Association-approved in 1930 and joined the American Association of Law Schools in 1931, adequate fund-raising had been unsuccessful. J. Ollie Edmunds, a Stetson graduate, trustee, and a Duval County judge, noted that a number of organizations in Jacksonville wanted the law school moved to their city. Mr. Stetson supported the move. The *Sun News*, DeLand's commissioners, and numerous civic organizations railed against the idea. The Jacksonville Bar Association offered to finance the school. By 1942, there were only 12 students and five teachers. The school was closed from 1943 to 1946 with no action for or against a move away from Flagler Hall and the DeLand campus.

Benjamin Franklin's bust sits atop the pediment leading into Flagler Hall giving one cause for contemplation. Franklin once said, "If a man empties his purse into his head, no man can take it away from him. An investment in knowledge always pays the best interest." His words rang true as thousands of veterans marched home from war. Men and women of all ages descended on America's campuses to take advantage of the G.I. Bill and, having lived through battles, wanted to gain something that no one could ever take from them. The war years had not been good for Stetson but when our soldiers returned home enrollment jumped from 362 in 1943 to 2,554 by 1947. Stetson was on the move. This was gratifying news for President Allen, but even as Stetson was gaining momentum Dr. Allen's health was deteriorating. He resigned September 19, 1947 and returned to his beloved Texas where he passed away in June 1951.

Two

Contemporary Times
1948–2005

Henry A. DeLand's dream that his town would become the "The Athens of Florida" was realized with the expansion of Stetson University. It was John B. Stetson who furthered the educational cause. Following in the pedagogical and entrepreneurial footsteps of these distinguished visionaries have been numerous men and women who diligently served as presidents, trustees, and donors for the university.

As President Hulley so eloquently espoused, "Education is the development of the powers of a human soul—Education is for life, and life is education." Through half a century Stetson University maintained the ideals of its early leaders. Its contemporary mission statement makes clear the direction in which the university moved through the last half of the 20th century.

Stetson's mission is to provide an excellent education in a creative community where learning and values meet, and to foster qualities of mind and heart that will prepare students to reach their full potential as informed citizens of local communities and the world.

At Stetson the art of teaching is practiced through programs solidly grounded in a tradition of liberal learning that stimulates critical thinking, imaginative inquiry, creative expression, and lively intellectual debate. The art of learning is enhanced through small interactive classes, close student-faculty alliances, and collaborative approaches that provide the foundation for rewarding careers and advanced study in selective graduate and professional programs. Stetson embraces diverse methodologies to foster effective communication, information and technological literacy, and aesthetic appreciation. The university encourages the development of informed convictions, independent judgment, and lifelong commitments to learning that are characteristic features of the enlightened citizen. In bringing together learning and values, the university encourages all of its members to demonstrate personal integrity; to develop an appreciation for the spiritual dimension of life; to embrace leadership in an increasingly complex, interdependent, and technological world; and to commit to active forms of social responsibility.

With Presidents J. Ollie Edmunds, John E. Johns, Pope A. Duncan, and H. Douglas Lee guiding Stetson toward the 21st century and with a mission statement such as Stetson's, how could the university not but grow in academic prestige and commitment to its students? These presidents' intellect, talent, and ability to work with faculty and staff on an equal level and their love of the students made them capable leaders during the post-war years, through the turbulence of integration and its accompanying battles for social justice and equality, through the agonizing years when students struggled to make sense of the Vietnam War, the numbing shock of President Kennedy's assassination, the violent deaths of Robert Kennedy and Martin Luther King Jr., as well as myriad other economic and social issues that followed.

Ushering in a new millennium, President Lee stood steadfast in his resolve that "The heart of Stetson University's commitment to excellence is found in its outstanding faculty." And indeed he is correct. For all the impressive structures on Stetson's campus, its endowments, and its educational programs, at the core of the university are its teachers and their students.

In 1948, Dr. J. Ollie Edmunds became the fourth president of Stetson. Dr. Edmunds, born in Georgia, later moved with his family to Jacksonville, Florida. Since he worked during the day to help support his family, he attended evening classes at the YMCA. During a church service in 1920 Edmunds heard Stetson President Hulley's sermon, "Angels in White." "This," said Dr. Edmunds, "brought me to Stetson." His family moved to DeLand where he was admitted "with conditions" since Dean Carson was unsure as to the caliber of schooling Edmunds had received. Edmunds' father became Stetson's Superintendent of Buildings and Grounds. During Edmunds' college years he held various jobs including campus janitor, reporter for the *Sun News*, and a clerk at Volusia County Bank. He proved to be an exceptional student and speaker. He earned a law degree in 1928 and at age 27 was appointed a Duval County judge. In 1934, he was elected to Stetson's Board of Trustees, remaining in that position until his appointment as Stetson's president. Dr. Edmunds was the only Stetson alumnus to serve as president.

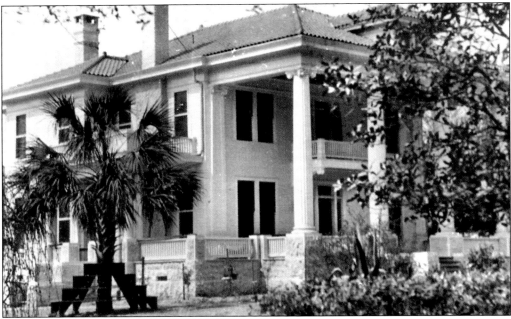

Stetson purchased this 1910 Neo-classic dwelling in 1948 to replace Holmes Hall as the president's residence. Located on the west side of Woodland Boulevard adjacent to Flagler Hall, it was an ideal acquisition. It was built for W.A. Steed, a shoe store owner, who often entertained Stetson students at his home. The house was later purchased by Judge J.W. Perkins, then James Williamson Jr., who used it as a winter retreat before it became part of the university.

There was a different feel to campus life after the war. Students returning to college seemed to take seriously their responsibility to improve the world. Yet the 1950s also ushered in a more carefree time, as evidenced by Stetson activities and antics. DeLeon Springs was still a favorite weekend retreat, but the bathing suits and behavior had changed from the pre-war era. Student recruitment took the approach that there was lots to do in the area, warm weather, and bushels of fresh oranges. After all, Stetson's campus boasted a sweet supply of oranges well into the 1970s. Of course there were always lots of pretty coeds.

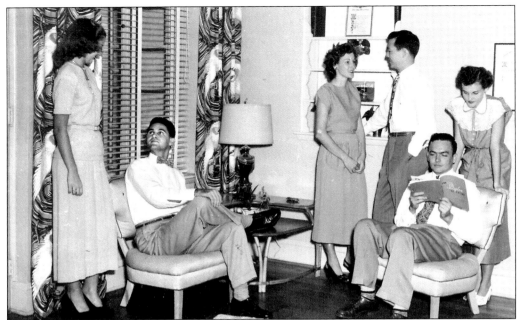

There continued through the 1940s a gentility of style and behavior with social skills and manners practiced and appreciated by both men and women. The reception areas were well appointed with comfortable furniture, draped windows, and all the proper accoutrements that made "dorm life" feel more like living at home. Times had improved for campus dating since the early 1900s when only on Saturday nights could male and female students intermingle in Chaudoin Hall's lounge. According to Dr. Lycan, "Students could not sit facing the wall, but had to face the center of the room. As soon as they were seated, the Dean of Women, Miss Ellen Martien, would come up and place a yardstick between their chairs, and say 'Stay this far apart.'" But thankfully the times were changing and students could date openly. Dressing up for the occasion, meeting their dates in Chaudoin's parlor, these young coeds were still supervised—at least for a time.

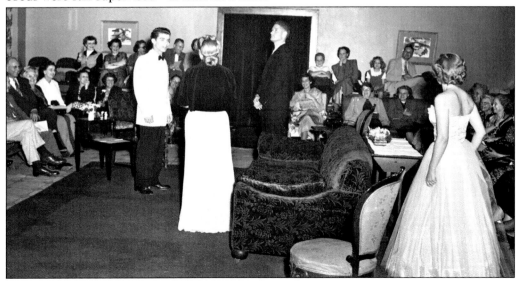

By the late 1940s, students were wandering about on their own, even dining out at the local soda fountain. Imagine what Presidents Forbes and Hulley would have thought about such behavior.

The 1942 Sigma Nu banquet at the Hotel Putnam was celebrated with white coats and bow ties, sequined dresses and corsages, and the ever-present chaperone and housemother.

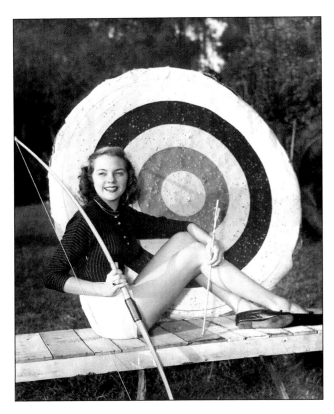

Student activities expanded to include archery, fencing, even dancing! In 1947 the Health and Physical Education Department offered a course for "all students who are interested in learning how to teach and direct Square Dance, Folk Dance, and Social Dance." During President Hulley's years he declared there would be no dancing on campus but students would always sneak off campus to dance the night away. With this new class offering, the Baptists rose up in dismay, demanding the course be cancelled. The trustees held firm; however the class description was re-written to read: "Teaching Rhythmic Activities. Materials for school and recreation programs. Folk, square, rounds, and contra."

The female archery team won the state championship in 1941, thanks to its able students and capable coach Sarah Staff. The women also came in second in golf. Tennis courts, constructed between Stover Theatre and Cummings Gym, brought rigorous practice from both men and women. 1941 also saw the women's tennis team place third in the state.

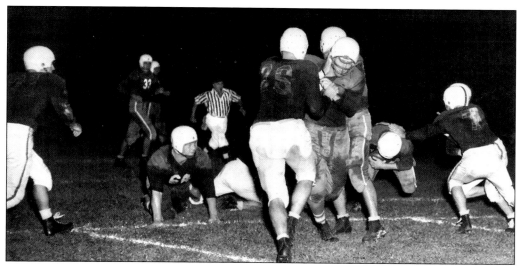

President Hulley required a strong athletic program "for the development of self-restraint, temperance in personal habits, cleanliness of body, determination of will, skill of eye and hand and brain, alertness in mental faculty, patience and endurance, fair dealing with opponents, cooperation with each other, obedience to authority vested in the coaches, and courage in meeting opposition." Whew! How about for fun? Even with all those reasons to continue football, the sport could not survive. Due to rising expenses, in January 1957, the trustees voted to abandon intercollegiate football.

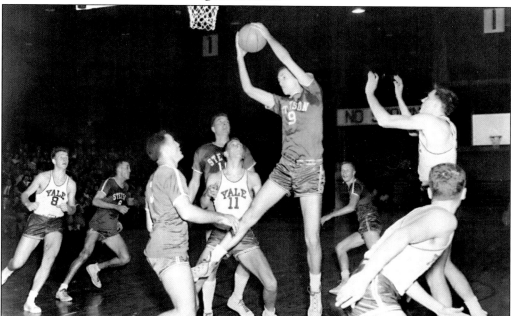

The same year that football ended at Stetson, basketball took a successful jump shot when Coach Dick Morland hired Glenn Wilkes as head coach. Wilkes's enthusiasm for the game, his relationship with students, his writings about basketball, and his successful camps created interest in the game. The team played in Hulley Gym but eventually moved in 1953 to the city's new armory on South Alabama Avenue.

Baseball continued to be a favorite sport, with the team hitting many more home runs thanks to the coaching skills of Doc Johnson and his exceptional selection of players.

Additional sports during those carefree post-war years also included boxing, wrestling, and fencing.

Additional classroom space was needed with the doubling of enrollment from post-war students. When the DeLand Naval Air Station donated several wooden structures to the university, the buildings were gratefully moved to campus. One was relocated behind Flagler Hall to house the Business School.

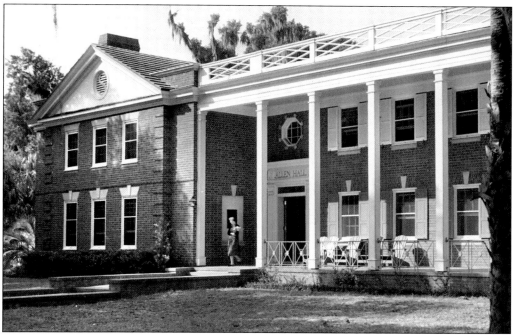

The Florida Baptist Convention built Allen Hall in 1950 on the west side of Woodland Boulevard at the corner of West Minnesota Avenue. Before other denominations built their own centers, it was shared by all faiths, later becoming the Baptist Student Center. It contains classrooms, offices for the Religious Studies Department, and a large meeting room with stage, lounge, and kitchen. It was also a terrific hangout for students in love. In fact, this author received her engagement ring in the upstairs classroom on the far left.

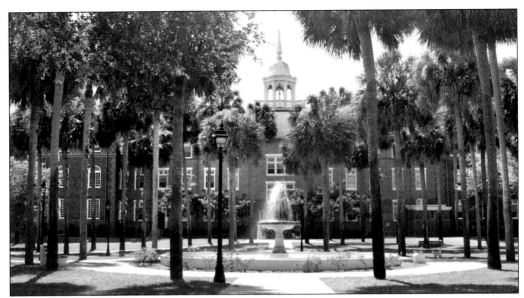

In the center of the quadrangle between Sampson and Elizabeth Halls is a particularly prominent historical element that lends itself to student conversation and relaxation—Holler Fountain. Art Deco in style, it was built in 1937 for the Florida Exhibit at the Great Lakes Exposition in Cleveland. It was also featured in the Florida display at the 1939–1940 New York World's Fair. The fountain was given to the university in 1951 by William E. Holler Jr. and Florida Exhibit coordinator Earl Brown, both of DeLand, in memory of William E. Holler Sr. Called an aqualux fountain for its water and light display, it has been known to entice daring students to toss soap suds or dye into the water, as well as a friend celebrating a birthday.

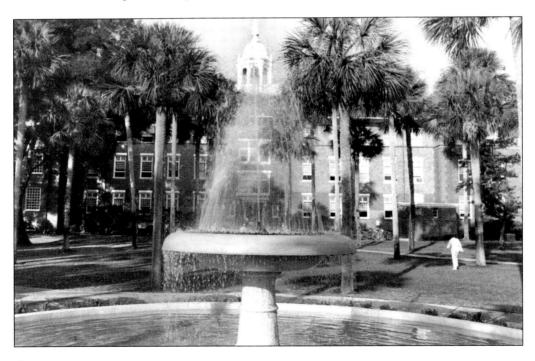

Fire struck Stetson's campus at Christmas 1954, burning the Commons, which housed the campus cafeteria. Hulley Gym's basement became the temporary cafeteria, and Morrison's Food Services was hired to supply meals to the students. With its entry on campus, fewer rumblings from the students' mouths and stomachs were heard. Even in 1921, students were writing of the woes of campus cooking in their list from "The Seven Stetson Wonders:" "I wonder if we'll ever have a meal without grits?"

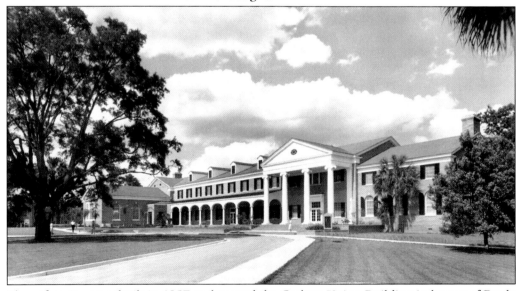

The cafeteria was rebuilt in 1957 and named the Carlton Union Building in honor of Doyle Carlton Sr., a Stetson graduate, past trustee, and former governor of Florida. Dubbed the CUB, it became the center of student activity, with housing upstairs, a large room for entertainment and offices, a cafeteria, and student and faculty lounges on the ground floor. The Hat Rack, Stetson's casual café, a patio, a post office, and a bookstore were attached to the north side.

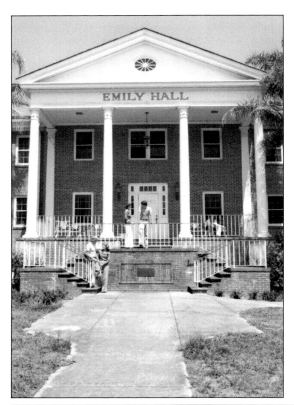

Student enrollment dwindled after the initial onslaught of veterans graduated, with a postwar loss of over 1,000 between 1947 and 1953. Enrollment climbed back to 1,502 in 1955, which led the university to replace several of its worn dormitories. North Hall, for women, was located at the north end of campus facing Woodland Boulevard. Gordis, Carson, and Smith Halls, for men, were completed between 1955 and 1957 and located on the east side of campus along Minnesota Avenue. During the 1950s and 1960s, men and women were appropriately separated. In 1962, North received an addition, and its name changed to Emily in memory of President Edmunds's wife. The men's dorms were named for Warren S. Gordis, acting president in 1895 and 1896; G. Prentice Carson, hired in 1887 as a history professor and later dean, who by student acclaim, "made history come alive;" and Dean J. Archy Smith, a popular math professor.

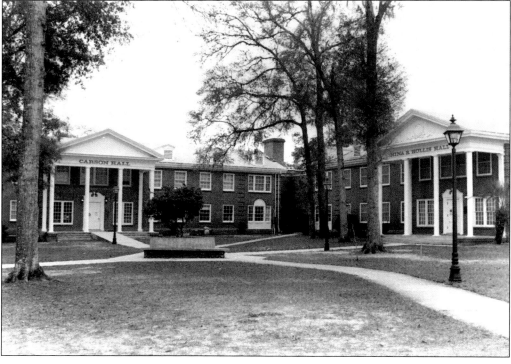

By the end of World War II, the School of Music was improving, and the Glee Club was making a name for itself. "Prof," as Harold M. Giffin was affectionately called, brought gleeful sounds back to campus. The *Sun News* proclaimed, "Stetson is a 'Singing University.' Its singers are called upon for all occasions . . . the fraternities hold intramural song contests."

The Music School was located in DeLand Hall, but when additional space was needed, a long wooden building was moved from DeLand Naval Air Station and relocated north and east of the historic building. The "new" building, unattractive and uncomfortable as it was, did not hinder the magnificent music that filtered through open windows and out onto the campus, nor did it discourage the concert choir from practicing for tours throughout Florida.

Richard M. Feasel joined the faculty in 1946. Soon, not only was Giffin's famous Glee Club traveling from state to state but so was the band. It made television appearances and played in the Orange Bowl in 1956 for the last Stetson-Miami football game. In fact, the band performed the day before the game on television for the station's first televised live program. The band performed regularly in local parades, but with the loss of the football team, the band had fewer opportunities to perform.

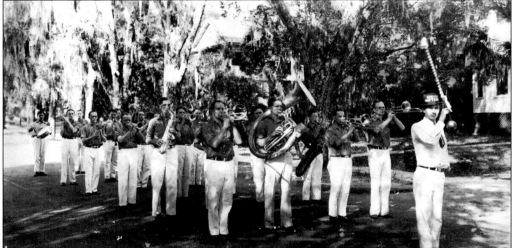

In 1952, at the age of 38, Claude M. Almand was hired as dean of the Music School. He was a gifted musician and composer. Stetson lost a remarkable and beloved man when his life was cut short in a 1957 car accident. His musician wife, Lenoir, remained at Stetson for another 40 years, carrying on her husband's legacy and eventually endowing a chair in composition. She instilled in many a student, including this author, both adoration and agony with her piano lessons.

Stetson's talented musicians have performed regularly in Elizabeth Hall since its completion in 1897, continually bringing honors to the school. Few universities can boast such a fine music school, a historic stage on which to perform, and a magnificent pipe organ to accompany students' voices and instruments.

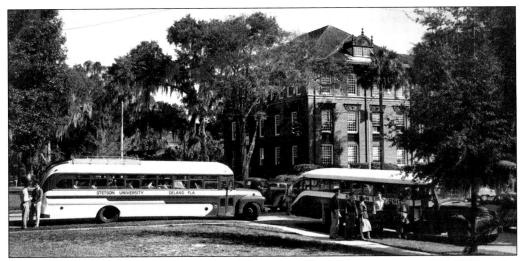

With the post-war enrollment explosion Stetson's College of Law relocated in 1947 to the DeLand Naval Air Station and students were bussed to and from the campus. By the 1950s, talk of moving it to another part of the state resurfaced. There arose such fervent protests from town folks that one outspoken woman even went so far as to write a letter to the editor of the *Sun News* exclaiming, "Possession is nine-tenths of the law." Several attorneys pleaded their case by promising DeLand would contribute up to $150,000 to keep the school in the city. Convinced that the law school was a financial drain on the university, no amount of arguing or offerings could stop Stetson's Trustees from approving the move.

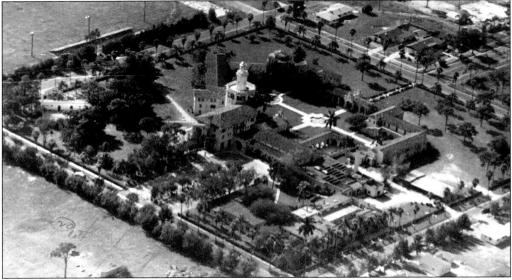

In 1954, a unique property was purchased for $200,000 in Gulfport, a short distance south of St. Petersburg. The complex of 17 buildings on 56 acres was built in 1926 during Florida's Land Boom. It was named The Rolyat Hotel, "Taylor" spelled backwards for the original owner "Handsome Jack" Taylor. The Land Bust caused by the Great Depression brought an end to extravagant vacations and thus ended but a few years of elegance for the Rolyat. The Florida Military School occupied the property from 1932 to 1951, then the compound remained vacant and deteriorating until Stetson's purchase three years later.

These Spanish Revival buildings with fountains and antique handmade tile and terra cotta roofs and towers were an opulent addition to Stetson University. The entry to the complex or the Plaza as it is called has two focal points; a circular tower known as the Granary Tower and the Main Tower, an octagonal reproduction of the Golden Tower of Seville. Prof. Everett Cushman described the new law school campus as "an array of battlemented walls and towers, heavily grilled portes and guarded doorways. The group of buildings encloses a great court, or Plaza Mayor, which represented the market place or outdoor gathering place . . . 18th century gateway . . . baroque love of curves and counter curves . . . decorated wooden ceilings . . . Spanish iron work."

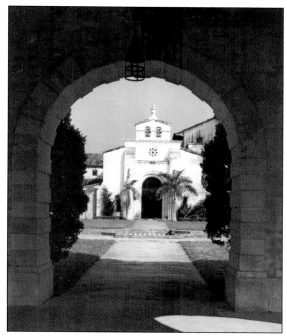

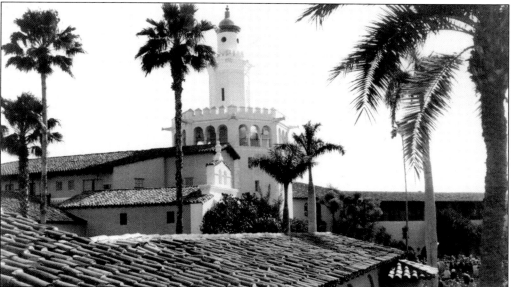

The Law School's move from DeLand to Gulfport was a monumental task with over 16,000 books trucked across the state. Donations for the project came from the City of Tampa, Charles E. Merrill, and the Avalon Foundation. Judge Harold Sebring, one of the most prominent jurists in the state, was appointed dean in 1955. Sebring was determined to put Stetson's College of Law on the judicial map. He initiated a 700-year-old program called "Inns-of-Court," a concept borrowed from England whereby students received room and board and professors joined them for meals. Inns-of-Court was promoted to encourage a more personal, lasting, and thus beneficial relationship between students and faculty. Sebring's plan worked so well that within three years enrollment more than doubled.

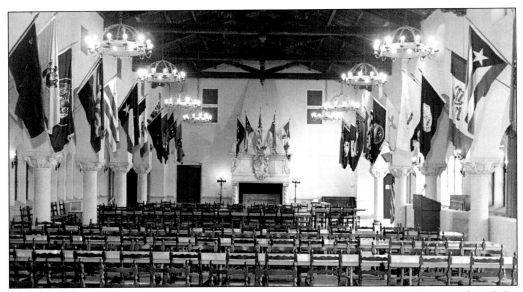

The Great Hall was used for dining during the building's days as the Rolyat Hotel and the Florida Military Academy. It is 48 by 96 feet with an imposing fireplace and arched alcoves. Flags representing every state and territory line the walls. Displayed over the fireplace are the five flags that have flown over Florida. The Flemish tapestry, believed to be woven in the latter part of the 17th century, was a gift from Harvey S. Firestone Jr. The Great Hall is used for lectures, awards ceremonies, and educational programs. The Charles A. Dana Law Library was constructed in 1956 with a substantial donation from the Dana Foundation. Harvey S. Firestone Jr. donated over $300,000 to construct recreational facilities. No longer was the law school a financial drain on the university. Pictured below at the fountain (from left to right) are Mrs. Firestone, President Edmunds, and Mr. Firestone.

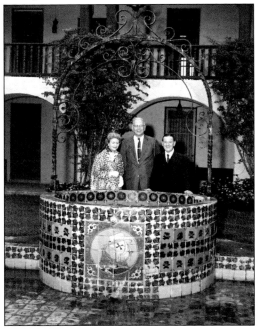

Stetson's academic calendar had gone from the semester to quarter system during the war. By 1951, professors and administrators voted for a return to semesters. Stetson was granted membership in the American Association of University Women in 1952. Between 1949 and 1959, faculty members holding doctorates doubled to 62 percent, with the national average at only 40 percent.

In 1955 the School of Liberal Arts received funds from Charles E. Merrill to create the innovative American Studies Program. Dr. John A. Hague (left) became head of the department and four years later Dr. Gerald E. Critoph (right) was hired. The program was a genuine attempt at an interdisciplinary, multi-media investigation of American culture. Professors Hague and Critoph, with Art Professor Fred Messersmith, integrated American ideas with its distinctive art and architecture. Many a student carried from their studies the ability to make remarkable intellectual and academic contributions.

During the 1950s, large numbers of students were awarded the prestigious Woodrow Wilson Fellowship. Fifty-eight percent of all university seniors were admitted to graduate school. By 1954, 33 percent of all Florida college graduates listed in Who's Who in America were Stetson students. President Edmunds reported to the board that Stetson has "the strongest academic community in the history of the University." In May 1957, Stetson organized its faculty senate. The president was Dr. Ray Sowers (left), vice president was Dr. Byron Gibson (right), and secretary-treasurer, Maxine Patterson. Dr. Sowers called the first meeting November 1957 to announce the election of Edmunds to the prestigious post of president of the American Association of Colleges.

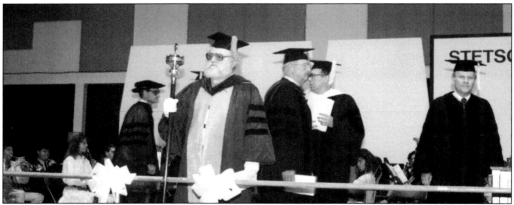

A regal tradition began in 1956 when Canon Edward Mason West donated, through Dr. Stover, an elegant mace created by one of the world's most renowned silversmiths, London's Daniel Spencer. Engraved on it is Stetson's motto, Pro Deo et Veritate, with symbols representing the City of DeLand, Volusia County, and the State of Florida. The mace, carried with dignity and honor by a faculty member, leads the procession in all university functions.

Stetson has always prided itself on being a "teaching school." Gilbert Lycan noted that President Forbes and Professor Suhrie created a program that "soon became the object of amazement in Florida." Dr. Sowers offered, "If you have any constructive criticism of our department, we shall be glad to consider it." Dr. Sowers agreed with Harvard president Dr. James Conant, who believed that "after a long study. . . the one and only part of the teacher training program that should be specifically required is internship." As Florida's population grew, so did the necessity for well-educated teachers. Dr. Sowers brought in Drs. Richard Copeland, George Hood, Ruth Smith, Harland Merriam, Richard Morland, Watie Pickens, T.E. Smotherman, and Frank Tubbs. In 1957, 45 universities applied to the National Council for Accreditation of Teacher Education. Only 18 schools were visited, with only six approved. Stetson was one of the six, strengthening graduates' credentials. Pictured are Dr. Smith (above left), Dr. Copeland (above right), and Dr. Hood (right).

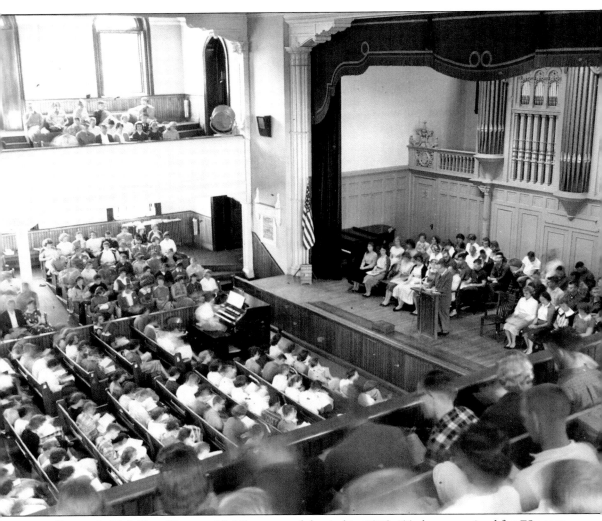

Stetson's 75th-Year Diamond Jubilee was celebrated in 1958. "To have survived for 75 years was an accomplishment, for hundreds of denominational colleges had long since ceased to exist," claims school historian Gilbert Lycan. But tensions were mounting with the Florida Baptist Convention. President Hulley faced criticism over students dancing on campus. President Edmunds faced the same complaint, always reassuring the Baptists that no one danced on campus and no school funds had ever been spent on such an outrageous activity. Of course, the administration was aware that students fled campus for that sport. Ministers began to warn Edmunds the school might lose their support. A university field representative informed the trustees that many Florida Baptist Church leaders were expressing the belief that "Stetson is not spiritual enough . . . it professes to be something that it is not." Although supervised dancing finally was allowed on campus in 1965, it appears that Stetson students still maintained their spirituality according to chapel attendance!

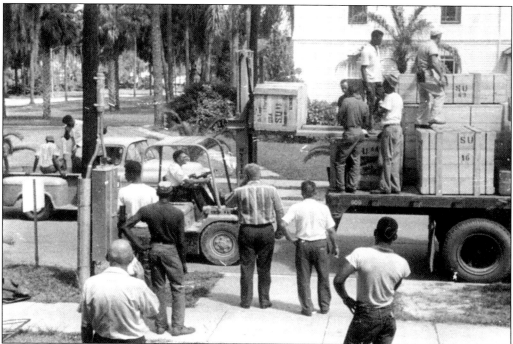

In 1961, an outstanding Beckerath organ was purchased by Stetson University, the first of its kind in an American university. Getting the parts delivered to campus and installed in Elizabeth Hall was a major project. Fifty-six crates were shipped from Hamburg, unloaded in Jacksonville, and trucked to DeLand. Three Germans from the Beckerath workshop spent two months erecting the new organ. The university did not own a mechanical hoist, so a local lumber company donated one.

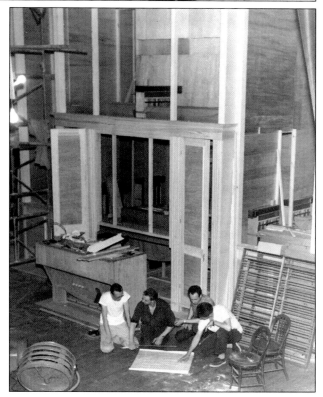

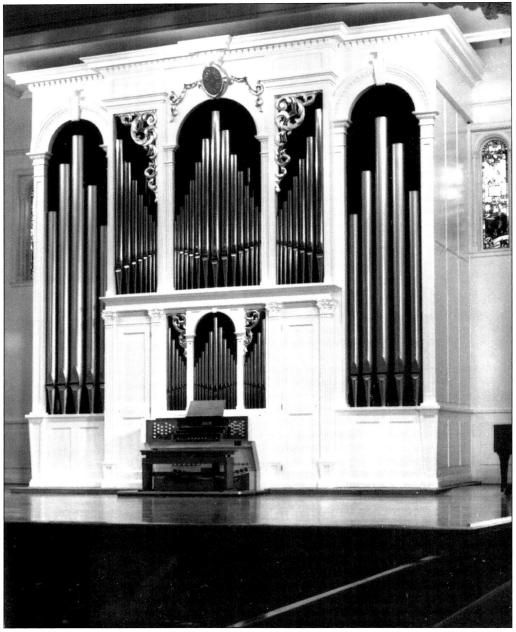
Though beautiful to behold, it is the human touch that brings life to this astounding Beckerath organ.

In 1962, due to a serious shortage of college teachers, Dr. Richard Morland, right, initiated the MA-3 program with funds from the Ford Foundation. Students in the program received experience teaching in junior colleges. Upon graduation nearly all of them were accepted at prestigious graduate schools, later attaining college teaching positions. Boasts Dr. Lycan, "The program was so spectacular that it almost defies belief." With another Ford Foundation grant in 1966 the program merged with Stetson's Honors Program.

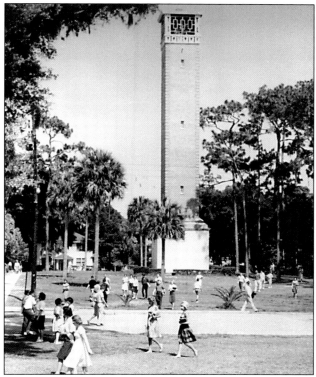

During the 1960s, a number of additional academic programs were established to enhance Stetson's curriculum. The 1960s brought many changes to the campus including early admission for advanced high school students. At the end of their junior year students attended summer sessions at Stetson. Many of the school's top professors participated in the team-teaching program. The program was successful, often reducing a student's college enrollment by a year. It is interesting to note that during this time coeds were not allowed to wear slacks to class. In this photo do you see any young ladies in jeans or shorts?

The Washington Semester, organized in 1963, offered select juniors and seniors the opportunity to study politics firsthand in Washington. Scholarship assistance was eventually established by a 1960s participant of the program, former United States Senator Max Cleland (D-Ga.), seen at left during his student days. This stimulating program continues today. Students of the 1960s were more demanding and anxious to become involved in issues than ever before. President Edmunds even suggested that the students give suggestions for improvement.

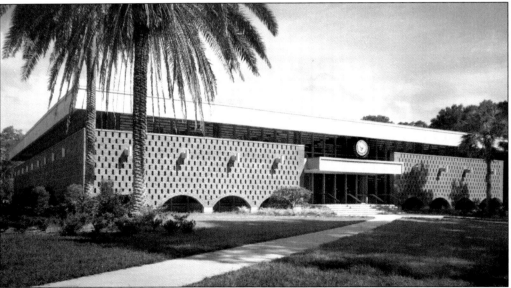

As Stetson's student population grew, so did the need for a larger library. Elegant and aging Sampson Hall's plaster walls were cracking, and the archives were filled to overflowing with narrow aisles and a dampness that endangered the collection. Edmunds attracted two major donors—Jessie Ball duPont and Edward Ball. Completed in 1964 at a cost of over $1 million, the duPont-Ball Library had 50,000 square feet. With this building Edmunds introduced "modern architecture" to campus, a theme that would follow him throughout his presidency.

Operation Booklift, May 7, 1964, brought together students, faculty, staff, and administrators who carried every volume out of the old and into the new. Over 100,000 items were moved, including chairs, tables, and card-catalogue files. A picnic lunch was served in the quadrangle. Participants were given a green-leather, gold-embossed bookmark to "mark" the momentous occasion. Dr. Edmunds, left, led the procession as it descended the worn granite steps of Sampson and walked the hundred strides to the duPont-Ball Library. This author took part, fondly remembering it as one of the most exhilarating times. The delight Dr. Edmunds displayed lifted everyone's determination and spirit. Pride over this accomplishment showed on his face and in his demeanor as he returned again and again to Sampson.

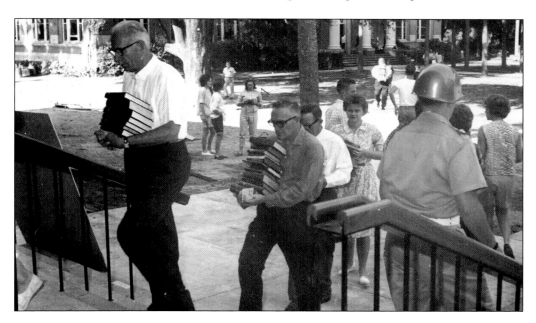

With the 1960s integration of schools and public facilities loomed across America but Stetson had addressed the impending challenge years earlier. "What is a Christian College?" a pamphlet written by several Stetson professors, was a powerful statement confirming the university's commitment to social justice. It acknowledged that "church-related schools are under particular obligation to speed the admission of Negroes as an act of Christian brotherhood." When the pamphlet was presented to the full faculty in 1951, they voted unanimously to accept it, ahead of their time as measured by the Florida Baptist Convention and Stetson's Trustees. In 1954, President Edmunds was asked by a prominent Baptist minister to accept a Nigerian student but Edmunds declined, admitting the time was not right. In 1960 Edmunds promised to "take the bull by the horns" and admitted Cornelius Hunter, a black student from Starke, Florida, who had graduated at the top of his class. When the trustees next met, having learned of Hunter's enrollment, Edmunds handled the situation with such diplomacy and skill that he quelled any impending disruption. Writes Dr. Lycan, "Edmunds considered this one of the greatest triumphs of his life." Neil, as he was called, worked in the library and graduated in 1966 with a degree from the College of Liberal Arts. After Hunter's admittance the landscape of Henry A. DeLand's "Athens of Florida" gained further fertile growth and variety with an influx of Cuban refugees in 1963. Their vibrant culture, demand for democracy, and zeal for knowledge brought a rich diversity to campus.

Soon more African Americans were admitted to Stetson including Jimmy Johnson, a four-year student and a talented addition to the Hatter's baseball team.

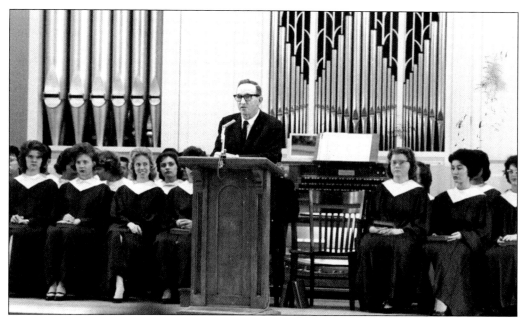

The 1960s ushered in many changes, including student dissatisfaction with mandatory chapel attendance. Dr. James A. Stewart, above, dean of the chapel since 1955, was deeply respected, his talks thoughtful, and his rapport with students and faculty admirable. But students wanted fewer restrictions and voiced their complaints. Stewart agreed, arguing with the administration "whether it was 'wise or right' to compel students to attend a religious service." In 1965, capitulating to the times, mandatory attendance at chapel was eliminated.

Back on the law campus in Gulfport, Dean Sebring worked diligently to improve the school. He designated three requirements for employing teachers. They had to be "young and energetic, but mature and experienced, retired judges and lawyers who had been highly successful, and a few younger men of great promise." Evidently he knew what he was doing because by 1966, the entire class passed the bar, averaging higher marks than students in all other state schools. The highest and second-highest grades were also achieved by Stetson students. By then the library also had increased its collection to 41,000 volumes.

Construction once again dominated the DeLand campus. In 1966, the business school had outgrown its barracks-style building, and it was demolished to make way for yet another modern building, Davis Hall. The Davis brothers, the largest Winn-Dixie grocery chain stockholders, contributed half a million dollars toward construction. That same year, the School of Business Administration became a member of the American Assembly of Collegiate Schools of Business.

No science laboratories had been added since 1902. When a government grant was received, the Florida Baptist Convention cut financial support, claiming the federal grant combined church and state. Edmunds then prevailed upon Mrs. Henry J. Sage of St. Petersburg, who donated the major portion of the $1.5 million needed to complete Sage Hall in 1967.

Stately brick gates, on which the university's seal was mounted, were built to designate the entry to the main campus off tree-canopied Minnesota Avenue between DeLand and Elizabeth Halls.

The Art Department from its earliest days has had a reputation for attracting gifted artists. William A. Sharp, nationally recognized, was one of the first. When he moved to California in 1904, he left behind portraits of Henry A. DeLand, John B. Stetson, W.N. Chaudoin, C.T. Sampson, and John F. Forbes. He designed the stained glass windows in the chapel and his *Christ Before Pilate* continues to reside on the north wall. With the new duPont-Ball Library, the Art Department gained additional space in Sampson Hall. Louis F. Freund, who came to Stetson in 1949, was nationally known, as is Fred Messersmith, a professor since 1959. Ceramists Gene Bunker and Dan Gunderson added a new dimension. After 19 years at the helm, Pres. J. Ollie Edmunds, endeared with the nickname "Jollie Ollie," retired. His last graduating class, the Class of 1967, saw many a tearful eye as students shook his hand for the last time. Before passing the diploma to this author's husband President Edmunds's grabbed that young man's hand and announced to the crowd gathered in the Forest of Arden for the ceremonies, "Well, here's a man that's not only getting a degree today, he got a new baby last week." That was the type of person Edmunds was: gentle, gracious, and giving. During his tenure he raised over $18 million for the university, the campus increased from 33 to 80 acres, nine buildings were constructed, enrollment doubled, and he helped educate hundreds of students who fondly remember him to this day. Indeed Jollie Ollie had earned a rest.

Dr. Paul F. Geren, Economic Counselor at the American Embassy in Libya, was appointed Stetson's fifth president in August 1967. He earned a Ph.D. from Harvard, served in numerous countries in the Middle East, and was past executive vice president of Baylor University. His first year as president he announced an $8 million campaign, but by year's end the school suffered from the largest deficit it had realized in several years. Further complications arose when the faculty realized that Dr. Geren made academic decisions and appointments independent of faculty and staff advice. There was one bright spot, however, during his administration. A swimming pool, requested since the 1880s, finally was built. The Olympic-sized, L-shaped pool was completed in 1968 at a cost of $85,000. It was worth every penny!

Although Dr. Geren was popular with Baptists because he had been a missionary, his failed presidency coupled with President Edmunds's acceptance of federal funds to construct Sage Hall led to a decade of serious economic decline. With urging from faculty, staff, and picketing students, Dr. Geren resigned in June 1969. Dr. John E. Johns, right, vice president of Stetson University, became acting president. The search committee interviewed candidates including evangelist Billy Graham. In April 1970, Johns was appointed Stetson's sixth president. He graduated from Furman University with a B.A. and from the University of North Carolina at Chapel Hill with a Ph.D. in history. In 1948, he was hired to teach at Stetson. President Johns secured for Stetson during his tenure close to half a million dollars from the Florida Baptist Convention.

Presser Hall, the Music School's new building, was completed in 1969 south of Elizabeth Hall and dedicated in 1970. Its design followed the modern architectural theme begun by President Edmunds. Built to support 200 students with only 70 enrolled, Johns asked Dean Paul Langston to orchestrate a recruitment program. Langston assigned the task to music professor Richard Feasel. Dr. Feasel was such a success at the task that within three years enrollment reached 155.

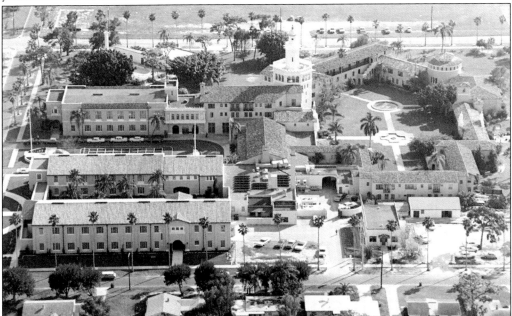

In 1969, with a generous donation from Eleanor Dana and Roy E. Crummer and a loan from the federal government, the law school acquired two new buildings—the Eleanor N. Dana Hall for administrative and faculty offices and the H. Jackson Crummer Hall, with 17 classrooms. These new buildings followed the historic architectural design of the original buildings constructed in the 1920s when the complex was the luxurious Rolyat Hotel.

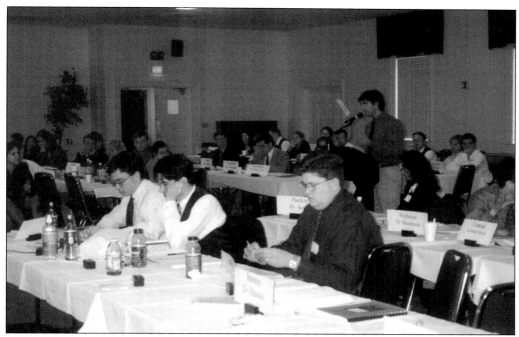

The Political Science Department, under the able leadership of Dr. T. Wayne Bailey and Dr. Gary L. Maris, initiated the Model Senate Program in 1971, the idea of student John Fraser. Students participating in the project played the role of United States senators. They held committee hearings and proposed, argued, and voted on various bills. Senators visited campus to meet with the students. This highly acclaimed program remains a continuing success.

The Edmunds Center, named in honor of J. Ollie Edmunds, was constructed in 1974 north of Emily Hall on the east side of campus and adjacent to fraternity row. It contains a large gym and offices. Basketball games were better attended once the sport was back on campus, having moved from the city armory. It also brought more townsfolk to the games, an attraction that continues up to the present.

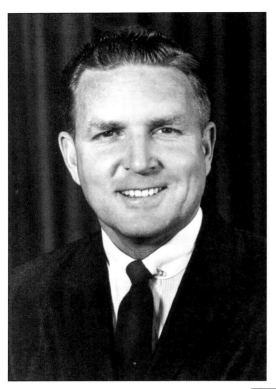

Wendell Jarrard Sr., left, Stetson Trustee and president of DeLand State Bank, so wholeheartedly believed in the project that his bank underwrote $1 million at only five percent interest. Johns summarized his feelings: " . . . it makes for good school spirit by bringing the students together for a common experience in which they are interested; it makes for good news coverage for Stetson, and binds the University and the City of DeLand closer together; the large seating area makes it possible to play basketball at a higher level, and with a smaller loss of money; and it provides adequate quarters for commencement and other large gatherings."

In 1976, President Johns left Stetson. Dr. Pope Duncan, right, a former Stetson Religion professor and then president of Georgia Southern College, was elected unanimously in April 1977 as Stetson's seventh president. Duncan earned his Bachelor's and Master's Degrees at the University of Georgia and Th. M. and Ph. D. at the Southern Baptist Theological Seminary. He taught at Stetson from 1946 to 1948, left for a year to teach at Mercer University, then returned to Stetson from 1949 until 1953. He was professor of Church History at the Southeastern Baptist Theological Seminary from 1953 until 1964, when he accepted a position as dean of Brunswick College. A year later he became president of South Georgia College at Douglas then moved to Georgia Southern where he was vice president. Offered Duncan, "Everything I learned along the way I found some use for as president." Duncan, author of four books, was a scholar and a gentleman.

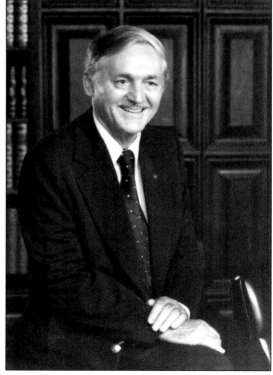

Duncan initiated Stetson's first major fund-raiser, a ten-year, $50-million campaign completed four years ahead of schedule due to the leadership of Stetson's vice president, Dr. H. Douglas Lee. The first $1 million was donated by a Stetson graduate and trustee, Kenneth Kirchman, right. Said Duncan of fund-raising, "Donors require attention from the president. Fund-raising takes time. It's almost like being in Congress; you have to start fund-raising on day one."

CAMPUS MASTER PLAN

- **LOOK TO THE FUTURE IN A MANNER THAT CAPTURES LONG-TERM STRATEGIES**
- **Protect and Preserve the Historic Character and Assets of the Campus**
- **Consider Infrastructure Issues**
 - Condition of Campus Facilities
 - Utility Distribution
 - Energy Conservation
 - Space Planning
- **Impact of Vehicular Traffic In and Around Campus**
 - Promote Pedestrian Friendly Access
 - Lessen Impact of Arterial Traffic
- **Environmental Stewardship**

When Dr. Duncan recognized the university's unique and historic structures were in need of major restoration and rehabilitation, he initiated his 1977 Campus Master Plan, the first ever for Stetson. The daunting and expensive task of rehabilitating Stetson's historic buildings took almost a decade to complete.

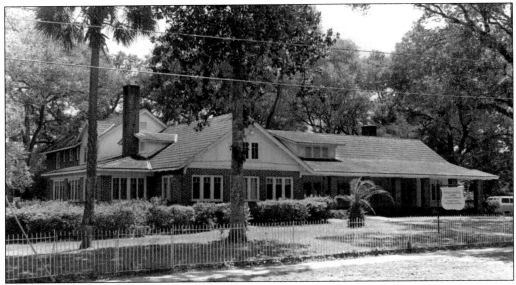

In 1978, a spacious home with attractive acreage south of Stetson was purchased to house the Geology and Geography Department. Located in this complex are the Gillespie Museum of Minerals, the second largest private collection of rocks and minerals in the United States.

Stetson University's centennial was celebrated throughout 1982 and 1983. Dr. Gilbert Lycan's *Stetson University: The First 100 Years* was published to commemorate the occasion. Writes Dr. Lycan, "Stetson is unique. The bond that has held the university together has been its devotion to Christian ideals. Those in control have always held that high standards of scholarship must be maintained." The setting for this event was on the old stage in the Forest of Arden.

In 1982, Stetson was awarded a chapter of Phi Beta Kappa, the oldest honorary society and one of the most prestigious in the United States. Stetson was the first private university in Florida and the third in the state to be thus honored. Membership in Phi Beta Kappa is based on academic merit and open only to students in the College of Arts and Sciences.

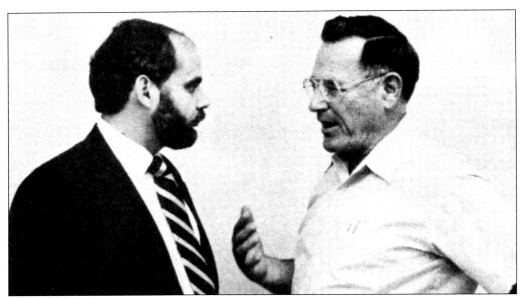

In 1983, the Finance Department of the School of Business Administration initiated the Roland George Investment Program, offering advanced education in portfolio management. The fund resulted from a gift in memory of investment specialist Roland George. He wanted students to receive firsthand experience making investment decisions. The program gives them a competitive edge, with practical experience managing a portfolio and buying stocks and bonds. Pictured are 1983 program director James Mallett at left and former program director Ken Jackson at right.

Students are responsible for earning sufficient income from the fund to pay the expenses of the program, including the costs of visiting professors, scholarships for outstanding investment students, and any additional equipment needed to forward the project. Today the program is such a success that the investment portfolio is worth well over $2 million, and students continually win top honors in national competitions.

A Master of Accountancy degree began in 1984. The College of Liberal Arts was changed to the College of Arts and Sciences, and the School of Music added a bachelor's degree in musical theatre. Chancellor J. Ollie Edmunds, pictured at right, whose relationship with Stetson University spanned over half a century, also died that year. In 1987, after 10 successful years, President Duncan retired. When asked to name the best thing he ever did for Stetson, he replied without hesitation, "Hire Doug Lee."

Dr. H. Douglas Lee was inaugurated the university's eighth president on November 6, 1987. Dr. Lee came to Stetson in 1978 as vice president for development, moving from a similar position at Wake Forest University. A native of Danville, Virginia, Dr. Lee holds a Bachelor of Arts degree in English from the University of Richmond; Bachelor of Divinity and Master of Theology degrees from Southeastern Seminary, Wake Forest, North Carolina; and a Doctorate in Religion from the University of Iowa. In President Lee's inaugural speech he pledged "to strengthen the academic distinction of Florida's first private university." Pictured from left to right are son Gregory, Mrs. Margaret Lee, President Lee, and daughter Elizabeth.

That same year, new sorority houses were dedicated. Built on the east side of campus facing Amelia Avenue and behind Conrad Hall, there are seven buildings in the complex.

The $200 million campaign was initiated in 1987 in an effort to increase the university's endowment, expand campus facilities, and provide additional scholarships. The Hollis Leadership Development Program was created that same year with a donation from the Hollis Family. The program furthers campus conversation about leadership, encouraging students to be passionate citizens and forceful campus leaders. The Leadership Program offers the community lectures, workshops, and internships and is the first in Florida to focus on the development of broad-based leadership skills. From left to right are Mark and Lynn Hollis, Dr. Duncan, William Hollis, and Dean Hollis.

Griffith Hall, constructed in 1989 to house admissions and financial aid, was made possible by a generous donation from the Griffith Foundation. Jack Griffith, vice president of the foundation, and wife Edna, above, met at Stetson, married in 1951, and graduated in 1952. President Lee initiated the plan to integrate Stetson's new buildings with its historic ones. The first example of Lee's effort was Griffith Hall, designed to blend with the architectural features of the adjacent Carlton Union Building and its red brick facade with white arches.

Stetson alumnus E.M. Lynn contributed $3 million in 1990 toward the purchase of a five-story bank building at the southern edge of the campus across from the President's Home. Renamed the Lynn Business Center, it was acquired in order to move the School of Business Administration from Davis Hall. With the Business School relocated, additional room was available for the philosophy, psychology, and education departments.

The historic preservation program initiated by President Duncan in 1977 and furthered by President Lee culminated in Stetson's campus being designated as a national historic district. The campus contains Florida's oldest educational facilities, featuring a distinctive blend of Florida vernacular, Victorian, and eclectic styles. Stetson's campus lends distinction and a sense of place to the city of DeLand and the city's proximity to the campus gives the university close ties to downtown.

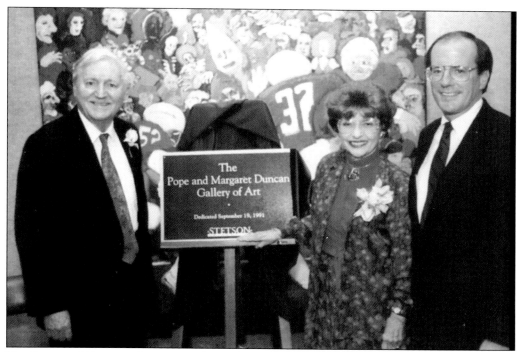

The Pope and Margaret Duncan Gallery of Art was dedicated in September 1991 in Sampson Hall. Sampson Hall underwent major remodeling to accommodate the art gallery.

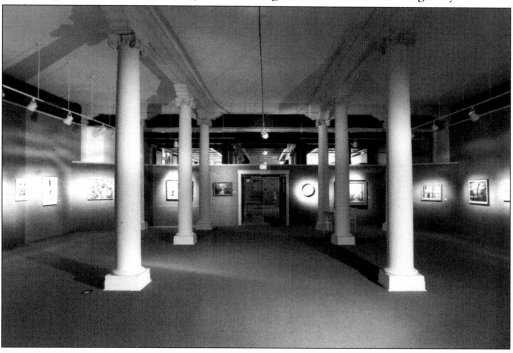

Also in 1991, the family of Stetson trustee and Publix grocery store executive Mark Hollis announced a $4.5 million gift, primarily for the William M. and Nina B. Hollis Scholarship Program. Merit scholarships for students with academic talents and leadership skills were established to assist those who might not otherwise be able to afford Stetson. Mark Hollis considered the ministry, accounting, and the military before deciding to join the grocery business. With a Stetson degree in Business, he started as a stock clerk, but was president of Publix by his 50th birthday. Hollis is pictured to the left, and his parents, Nina and William Hollis, are pictured below.

The Institute for Christian Ethics was begun as an extension of Stetson's Christian heritage which historically focuses on faith extended to practice. The Institute seeks to stimulate awareness of and critical reasoning about important ethical concerns in an ever-changing world. Its goals include promoting dialogue regarding ethical issues with prominent thinkers in religion, politics, education, environment, law, economics, medicine, and business; raising the awareness of standards that prompt decision-making and nurture sensitivity for valid principles of moral judgment; and encouraging the integration of academic studies and community involvement. The Christian Ethics Institute sponsors the Stewart Lectures Series in honor of James A. Stewart, who in 1955 became Stetson's first dean of the chapel. The lecture series has brought to campus such notable speakers as Archbishop Desmond Tutu, Elie Wiesel, Jimmy Carter, Bill Moyers, and Jane Goodall (bottom right).

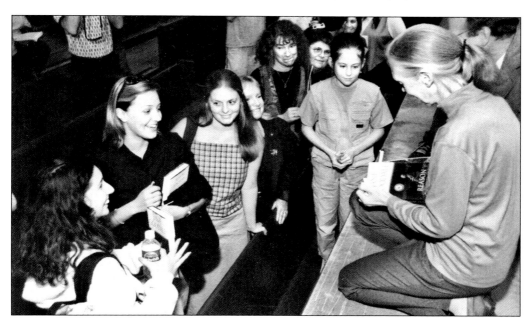

By 1993, the racial and ethnic diversity of the student population had grown from 99 minority undergraduates in 1988 to 180, assisted by a part-time Coordinator of Minority Affairs. Stetson appointed its first Adviser on Diversity Issues, Dr. Leonard Nance, in 1994. The university adopted a two-semester year, marking the end of the winter term, in 1993. New programs included university experience courses to help new students adjust to the academic setting and a minor in leadership development. And students of the 1990s began to participate more in planning through a revitalized Student Government Association.

In 1994, Mark and Lynn Hollis's family foundation financed an endowment to support existing and new innovative academic programs. The Hollis Renaissance Program, with an endowment totaling $10 million, supports a variety of programs, including Digital Arts, Sport and Exercise Science, the Family Business Center, and the Environmental Science Program. The capstone program focused on teacher education and culminated in the establishment of the Nina B. Hollis K-12 Institute for Educational Reform, directed by the Nina B. Hollis Distinguished Professor, Dr. Bette Heins. As part of their studies, teacher education students also get hands-on classroom experience in the community.

The Wilson Athletic Center was made possible through a substantial donation from Stetson trustee Patricia Wilson and her husband, Pat. Adjacent to the west side of the Edmunds Center, the 13,000-square-foot facility houses the Sport and Exercise Science Program and provides workout facilities, training rooms, and physical-therapy facilities for varsity student athletes. Colors used in the building were selected to match the historic palette of Elizabeth Hall. In 1995, the Mandy Stoll Tennis Center was completed adjacent to the soccer field on the east side of campus. The facility was dedicated in memory of Mandy Stoll, a Stetson women's tennis team member whose young life ended tragically in a car accident in 1988. The tennis center is a state-of-the-art facility and includes six hard courts with lights

The Hollis Center, located to the north of the CUB, was completed in 1995. A generous contribution was given by the Hollis family. Pictured from left to right are President Lee, Lynn and Mark Hollis, and artist and Stetson professor Fred Messersmith. The building integrated the red brick of historic Elizabeth Hall and included a stylish and modern cupola.

The Hollis Center is equipped with state-of-the-art exercise equipment to get students in tip-top shape. In the old days students walked or biked to class or downtown to shop. But as the years passed and more and more students brought cars to campus. Less walking often amounted to additional pounds. That in turn necessitated getting exercise from machines—while watching television, of course.

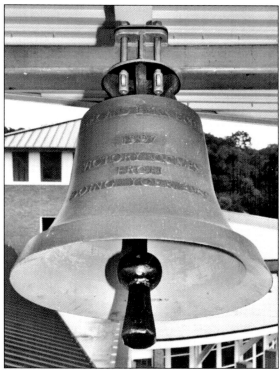

The Hollis Victory Bell frequently tolls Stetson's successes and special events.

Dr. David Rinker, a Stetson graduate and former chair of Stetson's Board of Trustees, and his wife, Dr. Leighan Rinker, a Stetson alumna, and Rinker's father, M.E. Rinker Sr., a former trustee for 30 years, have contributed generously to the university. Included are the Rinker Institute, Rinker Field, Rinker Field House at the Hollis Center, David and Leighan Rinker Scholarships for students who demonstrate a strong religious commitment, Rinker Guatemala/Nicaragua Field Experience, Rinker Scholarship for Travel Courses in Religious Studies, and the M.E. Rinker Sr. Foundation Scholarship. "By offering scholarships, we can affect the quality of the student body," affirms Rinker. "It's not just giving money to the university; it's giving to students. It's a wonderful opportunity to give, affect the lives of young people, and make the university a better place."

The major donors make it possible to complete construction of new buildings, remodel the old, and assure students that scholarships are available. Their contributions guarantee that Stetson has modern, state-of-the art facilities so that faculty can provide superior educational opportunities for their students. It is also important to have facilities to accommodate students wishing to develop their physical strength and athletic prowess.

Stetson's Howard Thurman Program, directed by the Rev. Jefferson P. Rogers, was established in April 1996, in partnership with New Birth, Inc., a national board of African-American leaders. Through the program scholars work to extend the legacy of Dr. Thurman, a leader of the American Civil Rights Movement. Thurman, a Daytona Beach native, was a spiritual advisor to Dr. Martin Luther King Jr., and was hailed by many as one of the greatest pastors of the 20th century. He was the first African-American Dean of the Marsh Chapel at Boston University. He was also co-founder of The Fellowship Church for All Peoples in San Francisco, the first interracially co-pastored church in America. Through the Howard Thurman Lecture series, Stetson hosts monthly world-class speakers who challenge the university's internal as well as external audiences to seek solutions to social, religious, and ethnic problems both in America and around the world. In addition to public lectures, each speaker visits classes or holds workshops with Stetson students and faculty, offering them new perspectives on social justice and encouraging them to go beyond the intellectual challenges of the classroom to work in forwarding justice in the world. Recent Thurman speakers have included Derrick Bell, Taylor Branch, Angela Davis, Cain Felder, John Lewis, Fred Shuttlesworth, Randall Robinson, Calvin Butts, and Andrea Young. Pictured above are the Reverend Rogers and President Lee.

Under President Lee's leadership, Stetson University continues to center its academic, campus life, and service programs on a rigorous examination of the values that support meaningful lives. To promote this goal, the University Values Council was created in 1998. There are seven strategic areas, with members of each group responsible for planning specific commitments to the university's values and vision goals. These areas include religious and spiritual life, ethical decision-making, diversity, gender equity, environmental responsibility, community service, and health and wellness. The examination of Stetson's mission and historic commitment grew out of a self-study the university began in 1998 as a part of reaffirming its accreditation by the Southern Association of Colleges and Schools. Discussions focused on the university's commitment to be an inclusive and caring community and to articulate its core values. People of all religious beliefs, people with no religious beliefs, people of all ethnic backgrounds, and people of different sexual orientations ultimately came to understand their inclusion in the university community.

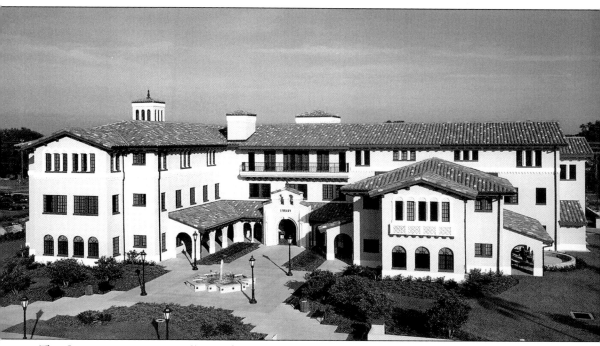

The Stetson University College of Law Libraries support the law school curriculum and faculty, staff, and court research. The 58,000-square-foot Gulfport law library is one of the most advanced legal research centers in the southeastern United States. It houses more than 394,000 volumes and is equipped for instant access to LEXIS/NEXIS, Westlaw, the Internet and Stetson's wireless network. Both the Gulfport and Tampa Campus libraries are open to alumni and to members of a bar association. The Law Libraries are a significant part of the Stetson University College of Law. They are enduring monuments to dedicated alumni and to the many friends of the College of Law whose contributions made their construction possible. The Law Libraries enable greater use of technology and the Tampa Library employs state-of-the-art wireless capability. Each library provides abundant study space for individuals and for small groups.

In 1999, Stetson's Undergraduate Scholarship Day was founded to foster an appreciation for student academic achievement. Students present their projects, portfolios, and research to the campus community. Judges rate participants in four categories: Oral presentations I and II and poster presentations I and II.

As the new millennium approached, Stetson students continued to excel academically. The quality of leadership and knowledge imparted by the faculty continued to assure that students were well prepared to face the challenges of a modern society and its ever-evolving needs. To support excellence in education, numerous scholarships were created, equipment updated, and books added to the library. By 2000, the university's endowment was well over the $80 million mark. And Stetson's enrollment was holding steady at approximately 2,500. Above, high school seniors visit campus to look over the facilities and meet some of the professors.

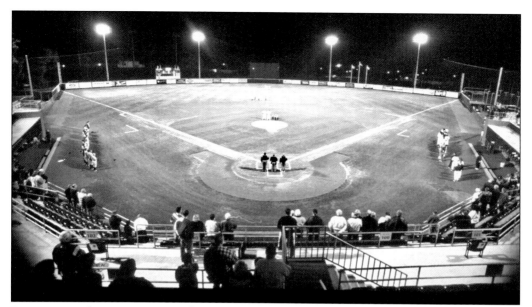

Recognizing that restoration is fitting for some buildings but that others need to be razed and rebuilt, Stetson University, the City of DeLand, and the DeLand Sports Redevelopment Association proved that its "Town and Gown" bond can accomplish great things. Working cooperatively, they completed Melching Field at Conrad Park in 1999 at a cost of $5 million after the removal of the old 1930s stadium. The new building, which used the red-brick pattern of historic Elizabeth Hall, was relocated to face DeLand's main thoroughfare, Woodland Boulevard. Baseball games continue to be enjoyed by both Stetson folks and locals.

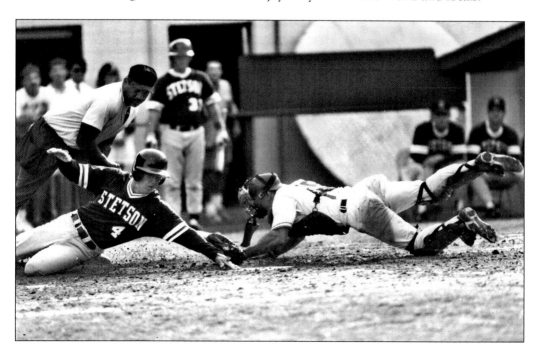

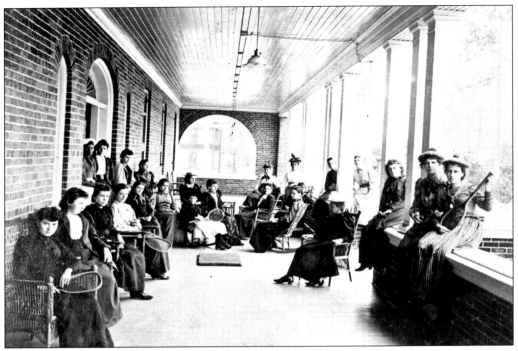

From the turn of the 20th century to the advent of 2000 and a new millennium, Stetson's small world evolved substantially and dramatically. To list those changes would take 1,000 pages, but as the saying goes, "A picture is worth a thousand words," so the juxtaposition of these two photographs, taken 100 years apart, depicts it all. No words are needed.

An important part of Stetson's Campus Master Plan is "Environmental Stewardship." To further this goal, Stetson addressed the necessity for energy conservation that includes the installation of a central chilled water loop serving 27 buildings, and a central heating loop, with solar assist for Smith, Gordis, and Nemec halls. Stetson received the Florida Sustainability Award in 2000 and again in 2003 for its leadership in environmental responsibility.

Stetson students are environmentally conscious, having organized in 2000 "Roots and Shoots," a club to promote care and concern for the environment, animals, and the community. The idea for this club sprouted from seeds planted during Jane Goodall's visit to campus. "Roots and Shoots" is part of the Jane Goodall Institute's international environmental and humanitarian program for young people. Stetson students adopt projects ranging from cleaning rivers and beaches to educating the campus community on ecological issues. They teach elementary school students environmental art, for which they have received several awards. Habitat for Humanity uses students to assist in cleaning neighborhoods and building homes for the needy. Club members also adopted the grounds of the Gillespie Museum of Minerals, taking on the project of landscaping the area with native plants.

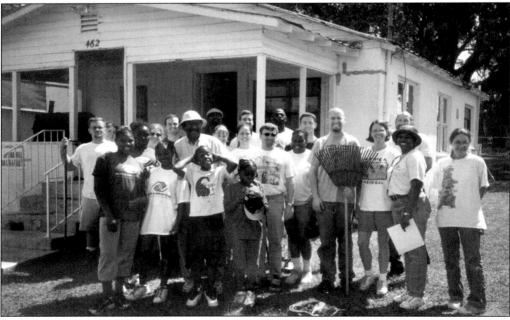

The university formed a volunteer partnership with the Spring Hill community in DeLand. Students attend Boy Scout meetings and interact with scouts and mentors; assist at Sugar 'N Spice Daycare Center with daily activities for children, serve as substitutes, read to students, and help with meals; mentor elementary, middle, or high-school students one on one; work with DeLand Family Center to provide counseling, support, and tutoring to children; volunteer at Chisholm Center in activities such as tutoring, sports, mentoring, and special events; assist the DeLand Police Department and its Police Athletic League in providing organized sports and recreation; work with the Spring Hill Boys & Girls Club on school programs providing sports and tutoring activities; teach art and environmental lessons at Southwestern Middle School; and join with Stetson's Education Department to provide partnerships in tutoring, reading, and technology.

The year 2001 was filled with new starts and grand achievements for Stetson, including the Cross Cultural Center and Multicultural Student Council organizing the university's first Gospel Choir. The group is open to all students, faculty, and staff, regardless of race, color, and creed, and represents campus diversity at its talented best. Explains Terrance Lane, a former Gospel Choir director, "Because modern and contemporary gospel music and Negro spirituals are historically at the core of the African-American church and community, they reinforce a positive sense of cultural identity."

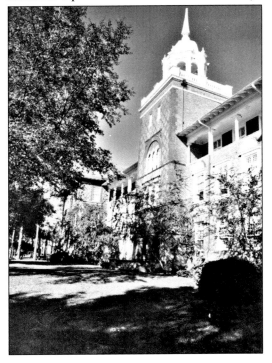

The university continued its restoration and rehabilitation program in 2001 by completing work on historic Elizabeth Hall. For this achievement, the university earned the Florida Preservation Award for "Recognition of Outstanding Achievement in the Field of Restoration/Rehabilitation."

Another monumental achievement for Stetson University was the opening in September 2001 of its $7.2 million, 36,000 square-foot building at Celebration, Florida. Situated on 1.1 acres, the building, designed by the New York architectural firm of Deamer and Phillips, uses a semi-circular continuous façade, avoiding front, back, or side distinctions. The architects blended the center's design with bordering wetlands. With a window in every classroom the pristine wetlands provide an aesthetic view for faculty, staff, and students. Shades of wetland green are incorporated into the center's interior décor and complement the exterior. It offers graduate studies in Business, Educational Leadership and Counseling; in-service training for teachers and other educators; and support for a professional development school relationship with Celebration School. Stetson is affiliated with the Florida Virtual School to administer an accredited on-line middle school and high school to out-of-state and international students seeking virtual high school educational opportunities, and with The Academy, an organization providing mortgage banking and real estate education. The Stetson University Center at Celebration is an exciting place, where the ultimate in teaching and learning occurs in a technology-rich environment. The center offers Master's Degrees in business administration, marriage and family therapy, school counseling, and educational leadership. Several additional academic programs are under development."

The school's 2000-2001 self-study committee partnered with the Values Council chairs to ensure that the university's values commitments were integrated fully into Stetson's revised mission statement. At the same time curricular, co-curricular, and community service programs were budding from grassroots sources. The SACS Self-Study Visiting Team concluded its evaluations in February 2001, giving Stetson a special commendation for its programs integrating values throughout the life of the university.

In 2002, Stetson's Board of Trustees named Dr. Pope Duncan Chancellor Emeritus, the second chancellor in Stetson's history, the first being J. Ollie Edmunds. Asked what changes he'd seen on campus since coming to Stetson in 1948, Duncan replied, "I've seen a lot of changes. I was teaching here when Stetson's budget went over $1 million for the first time . . . We didn't have sabbaticals or a pool of money for equipment. I remember my first office. I bought my own desk to replace a rickety table. I brought in my father's swivel chair. If we got a bookshelf, we thought we were doing well."

In 2002, the Lynn Business Center underwent a $12.6 million reconstruction thanks to the generous donation of $10 million from Christine Lynn in memory of her late husband, Eugene M. Lynn, a Stetson alumnus. The architectural design was developed under Stetson's guidelines to integrate the color palette and building materials with the university's historic buildings. The Eugene M. and Christine Lynn Business Center is the first in Florida to be certified a green building by the U.S. Green Building Council under its Leadership and Energy and Environmental Design (LEED) Green Building Rating System. Stetson University is solidly committed to environmental responsibility. Faced with the need to virtually demolish and rebuild the Center to meet students' needs, the school decided to do both in the most environmentally responsible way.

The center has an additional 13,000 square feet with the Wands Center for Information Technology, made possible by Thomas Wands, and a 144-seat auditorium through a contribution from the Marshall and Vera Lea Rinker Foundation. Mrs. Lynn is proud of the project, stating, "My late husband . . . credited his study at Stetson with much of his business success. That this wonderful facility, with its state-of-the-art classrooms and computer labs has also been certified as a Green Building is a tremendous plus." The Lynn Business Center has won other national and regional awards for design. The facility received the ABC Inc. 2003 "Excellence in Construction" Award of Merit and the 2003 Architectural Portfolio Educational Design "Excellence in American Schools and Universities" Award.

DeLand Hall underwent a major restoration in 2002 with the project partially funded by a $350,000 state historic preservation grant. Work included re-painting the exterior its original colors, repairing exterior siding, solid doors, and the original sash windows. The Florida Trust for Historic Preservation designated the project to receive its coveted "Outstanding Achievement" Award. DeLand Hall, Florida's oldest building in continuous use for higher education, was listed on the National Register of Historic Places in 1983. Since its construction in 1884 it has served as a library, chapel, classrooms, gymnasium, fraternity house, women's dorm, kindergarten, and speech, theatre, and music departments, and currently houses the president's office. The building has a fine collection of Stetson artifacts including an antique clock from John B. Stetson's home in Philadelphia as well as numerous historical photographs.

Stetson is not only concerned with preserving its historic structures, it is also dedicated to the conservation of its natural resources and the re-introduction of native plants, shrubs, and trees. The term "native" means vegetation growing in Florida prior to the 1513 arrival of Europeans. The project to re-plant the 170 acre campus by removing non-native growth will help to restore the natural ecosystem as well as promote the conservation of water and fertilizer. Students and faculty members are excited about the project and get personally involved with hands-on experience in digging, planting, and nurturing.

Stetson University's Women's Fastpitch Softball Field, completed in 2003 on the east side of campus, is the first Stetson athletic facility built solely for the use of female student-athletes. The previous year, the Lady Hatters earned their first-ever national ranking. The complex was named the 2003 and 2004 Regional Winner of the National Fastpitch Coaches Association/TURFACE Field Maintenance Award.

Soccer continues to be a favorite sport among Stetson students, both male and female, with teams consistently bringing honors to the school.

Amazingly, a rare and unexpected situation occurred in 2003, when Henry A. DeLand's great-great-great niece, Kaleena DeLand (left), and John B. Stetson's great-great-granddaughter, Carly Stetson (right), coincidentally enrolled at Stetson. Neither had known the other before "coming home." Said Kaleena, "I've known about Stetson all my life. This is the only school I ever wanted to go to." Carly noted, "A lot of people automatically assume that because of our last names we got a free ride going here. We got here purely on our own grades, our own scholarships. We got nothing for our last names." (Photo courtesy of *Daytona Beach News-Journal*, Peter Bauer.)

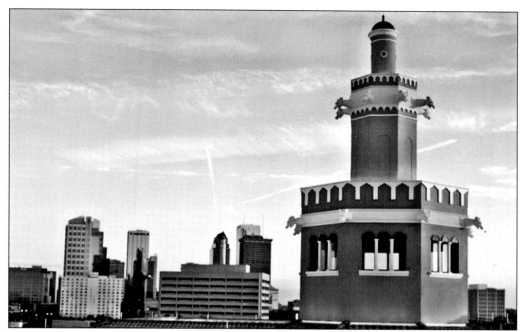

The Stetson University Tampa Law Center is rapidly developing into a major hub for legal activity in the Tampa Bay area. The campus offers evening courses for the Juris Doctor degree, and the Tampa branch of Florida's Second District Court of Appeal occupies the third floor of this magnificent campus. This unique public private partnership between a working court and a law school is the first of its kind in Florida and one of the first in the United States. The three-story, 73,500-square-foot building reflects the same Spanish-Mediterranean Revival architecture of Stetson's Gulfport campus. Stetson's signature tower, modeled after the Torre de Oro in Seville, Spain, is also replicated at the top of the Tampa Law Center. Eight friezes, which depict poignant moments in legal history, surround a custom-designed candelabra at the center of the W. Gary Vause Atrium. Artwork from a number of Florida artists accents the design of this spectacular new campus.

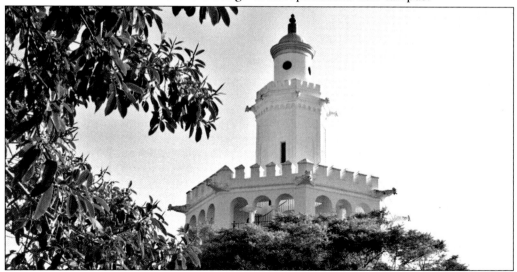

STETSON'S NATIONAL REPUTATION IN THE FIELD OF ADVOCACY INCLUDES:

National Trial Competition
The first law school in the nation to win four times

ATLA National Student Trial Advocacy Competition
The first law school in the nation to win first and second place in one year

NITA Tournament of Champions
Five first-place wins in the competition's history

National Association of Criminal Defense Lawyers Trial Competition
Three first-place wins

ABA Criminal Justice Trial Advocacy Competition
The only law school in the nation to win six times

Chester Bedell Memorial Mock Trial
First place in this competition 15 of the last 20 years, finishing first and second nine times

AFTL Student Mock Trial Competition
More first-place wins than all the other Florida law schools combined, finishing first and second seven times

Willem C. Vis International Commercial Arbitration Moot Competition
2005 world champions, first American law school to win since 1996

In the last 20 years, Stetson's Moot Court Board has won 23 competitions, 27 brief awards, and 33 oralist awards.

Effective advocacy is among a successful lawyer's most important skills. Stetson University College of Law ranked first in the nation for trial advocacy training in the 2006 graduate school rankings from U.S. News & World Report. The magazine also recognized Stetson's legal research and writing program, which tied for third in the nation. Stetson has an outstanding record of first-place victories in state, regional, national, and international competitions. Stetson was the first law school to win all five national trial competitions in one academic year. Membership on Stetson's trial team is a prestigious accomplishment. Stetson University College of Law became the first American law school since 1996 to win the 2005 Willem C. Vis International Commercial Arbitration Moot competition, held in Vienna, Austria. Teams from 150 law schools in 47 countries competed. Serving on Stetson's award-winning Moot Court Board polishes oral and written advocacy skills. Through domestic and international Moot Court competitions, students compete in a variety of legal subjects. Students also have the opportunity to compete for positions on Stetson's Client Skills Board which focuses on client counseling, negotiation, and mediation. The Center for Excellence in Advocacy at Stetson coordinates all advocacy training.

"From the first day I visited Stetson, I fell in love with the campus and the people I met. You are not just a number at Stetson; your experience is much more personalized. Every professor has an open-door policy, and every dean makes time for you whenever you need it," acknowledges a second-year law student. Confides another former student now practicing law, "One often hears lawyers state that their law schools did not prepare them well for the practice of law. That was not my experience at Stetson. My professors provided me with many of the necessary skills that have proven invaluable to me in the day-to-day practice of law." Pictured above is a view of the courtyard, or Plaza Mayor, at the Law School campus in Gulfport.

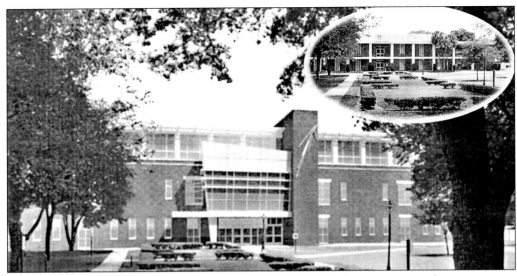

The College of Arts and Sciences has vision for the future, with the addition of 20,000 square feet to the university's science building, Sage Hall. Although interior remodeling has been on-going for several years, the major work has yet to begin. Notes Dr. Grady Ballenger, dean of the College of Arts and Sciences, "We want to announce to the world that science is central to our liberal arts education." Sage Hall will still house biology, chemistry, physics, biochemistry, environmental science, molecular biology, and integrative health science, as well as aquatic and marine biology, one of the most popular disciplines. The program focuses on freshwater ecology, taking into account the valuable resources of the area, especially the St. Johns—Florida's "American Heritage River"— and Blue Spring in Orange City. Stetson Aquatic and Marine Biology students even restored a portion of the boil at Blue Spring State Park. Explained Dr. Kirsten Work, "The boil itself is round and has steep banks leading to two observation decks where the ground was eroded very badly. We refilled holes and terraced the landscape with 635 cubic feet of dirt to replace what had washed away. It took weeks of hard work."

Alumni remain committed to "Give Stetson to a student" as a theme for the future. As one graduate explains, "Giving money for remodeling and building is necessary, but giving money to students so they can receive the same exceptional educational experiences we gained at Stetson is absolutely the most gratifying gift of all. It's the ultimate in investing in the future. Invest in the life of a child and you leave this world a far better place than when you arrived."

The year 2004 ended with a generous gift from a former DeLandite, in memory of the Very Reverend LeRoy Lawson, Rector of DeLand's St. Barnabas Episcopal Church from 1947 until 1966. He was also a philosophy faculty member at Stetson from 1952 until leaving St. Barnabas. "With authority, humor, and gentleness, he encouraged me and countless others in the lifelong pursuit of truth through reason and faith. Stetson, whose students he so dearly loved teaching, is the place where his values should be encouraged to flourish," said the donor, Martha Apgar. Included in the gift is an elegantly refurbished room in Elizabeth Hall designated as the Lawson Seminar and Reading Room, pictured below.

Further generosity in giving Stetson to a student is found in the recent Rob Brady Memorial Scholarship in the Humanities endowed by the Philosopher's Information Center to honor Dr. Brady, longtime Stetson philosophy professor and PIC board member. The scholarship is designed to help successful Stetson Humanities students who have trouble meeting their costs due to changed family circumstances with preference going to Philosophy majors or minors and/or those who are the first in their families to attend college.

In January 2005, Stetson University paid tribute to the Rev. Hal Marchman with an endowed chair in honor of his life's work and community ministry. The Hal S. Marchman Chair of Civic and Social Responsibility will be funded with a $2 million endowment, the largest ever for an endowed chair at Stetson. J. Hyatt and Cici Brown made the lead gift, and the university raised additional funds to complete the endowment. Brown is chair and chief executive officer of Brown & Brown Inc., the largest insurance organization in Florida and the nation's eighth largest insurance intermediary. He has also been a member of Stetson's Board of Trustees for 23 years. Cici Brown has served on the board since 1999 and is currently a member of the executive committee. Marchman was the longtime Daytona International Speedway chaplain known for his nationally televised prayers before NASCAR races. He gave the invocation before every Daytona 500 from 1962 when it started through 2004. For many years he stayed at the track's infield care center during races to help families and pit crews in case a driver was injured. Marchman is also known locally for his ministry with alcoholics and drug addicts, prisoners, the homeless, elderly, and at-risk youth. He was pastor of Central Baptist Church in Daytona Beach for 28 years, established the Stewart-Marchman Treatment Center in Daytona Beach in the 1970s, and served on the university's board for nine years. Both he and his wife, Mary Mathis Marchman, are Stetson graduates. Seated in the middle is Mrs. Marchman. To her left is Reverend Marchman.

In February 2005, Stetson endowed a Creative Writing Program with $3.5 million, thanks to the generosity of a couple motivated by love of literature, reading, and writing. The Creative Writing Program will permanently fund 15 scholarships for creative writers, five creative writing courses each year, and visits to campus by well-known writers, such as former U.S. poet laureate Mark Strand. It also will enable the English Department to send students and faculty to writing conferences and give annual creative writing awards to students. Students will be able to earn an academic minor through the program. A capstone for the program is an endowment for a distinguished chair in creative writing. Establishing the faculty chair brings national recognition to Stetson's writing program and will help the university recruit the best creative writing students.

The Future

2006 AND BEYOND

Values and vision propel Stetson University forward into its future because Stetson took bold steps during the last two decades to achieve extremely ambitious goals. Capitalizing on the hard work and vision of its founders and leaders, the university continues to integrate values into the teaching and learning process through continual improvement of its academic programs. For these reasons Stetson is positioned as one of the nation's premier private universities.

From one small building on four acres in DeLand, Florida, Stetson has, almost 125 years later, evolved into a university with four nationally recognized colleges and schools in four Florida locations. The College of Arts and Sciences, the School of Business Administration, and the School of Music are on the historic main campus in DeLand. The new interdisciplinary Stetson University Center at Celebration is near Orlando. The College of Law is in Gulfport, with an additional campus in downtown Tampa. Evolving from a single frame structure in Persimmon Hollow, Florida, Stetson University now stands as a premier university in the Southeast, poised to serve national and international communities.

Stetson's motto, Pro Deo et Veritate—"For God and Truth"—is the vibrant message the university will carry into its future: Our quest for truth must be intertwined with spiritual life and commitment to justice and social responsibility. Since its founding in 1883, Stetson has affirmed this message, determined to integrate the pursuit of a liberal education with the search for meaning in its students' lives and in the community as well.

Stetson's future surely will remain steadfast as it upholds its educational mission. At the same time, the university will continue to develop distinctive, innovative, and interdisciplinary undergraduate and graduate programs centered on vigorous intellectual inquiry. And academic programs will continue to provide a global perspective through ethical and social values worthy of the school's students and professors.

As the torch bearing the combined flames of values and vision is held high to light Stetson's path into the unknown, so too will the university's profound commitment to teaching illuminate the university's future obligations to its students. Stetson will always provide an excellent education in a creative community where learning and values meet, fostering in students the qualities of mind and heart that will prepare them to reach their full potential as informed citizens. And although Stetson's administration, staff, and faculty can learn from the past, it is critical that they think of the future. They must never lose sight of their primary goal: to offer their students the best possible opportunities for learning.

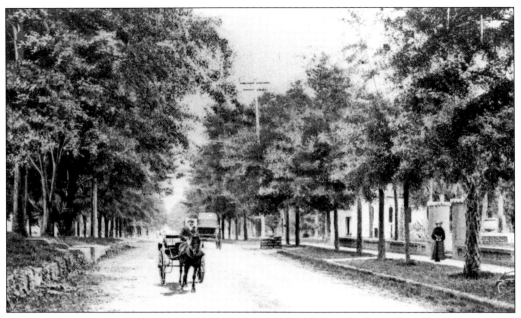

From the early days when the horse and buggy clopped and rolled down dusty tree-lined Woodland Boulevard, from DeLand Academy to DeLand College to John B. Stetson University then Stetson University, the school has journeyed a route as bumpy as the shell roads of yesterday and as smooth as the asphalted roads of today. Stetson has traveled hand-in-hand with the residents of DeLand as the city prides itself on being the "Athens of Florida" because it has Stetson University. And because Stetson University has DeLand, the "Town and Gown" tradition of cooperation surely will continue. Standing in the chime room of Hulley Tower, casting a wistful glance across the campus toward town, past historic Elizabeth Hall's cupola and beyond the dome of the historic county courthouse, let us pray that the future portends only the very best for both.